THE
Archive Photographs
SERIES

PUTNEY
AND
ROEHAMPTON

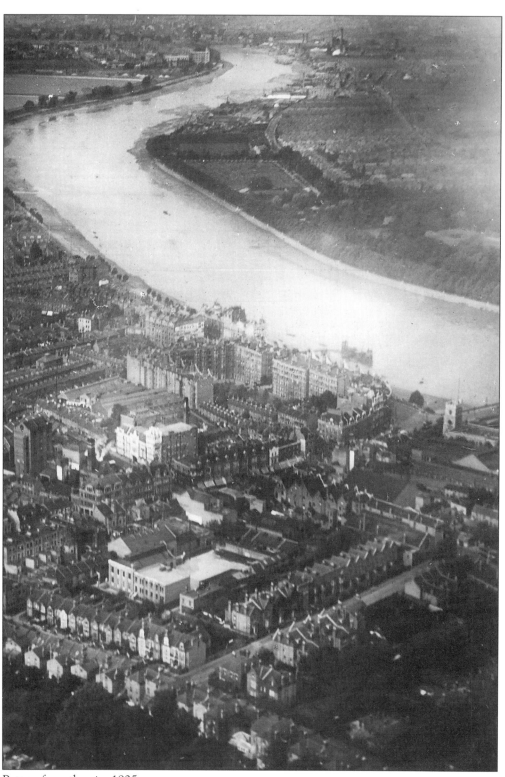

Putney from the air c1925.

THE
Archive Photographs
SERIES

PUTNEY
AND
ROEHAMPTON

Compiled by
Patrick Loobey

CHALFORD

First published 1996
Copyright © Patrick Loobey, 1996

The Chalford Publishing Company
St Mary's Mill, Chalford,
Stroud, Gloucestershire, GL6 8NX

ISBN 0 7524 0632 9

Typesetting and origination by
The Chalford Publishing Company
Printed in Great Britain by
Redwood Books, Trowbridge

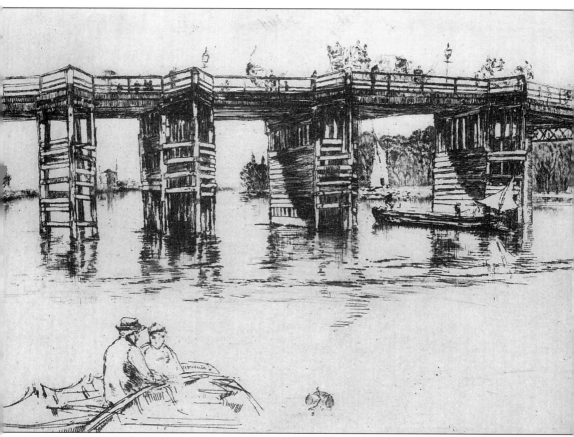

Putney old bridge c1880.

Contents

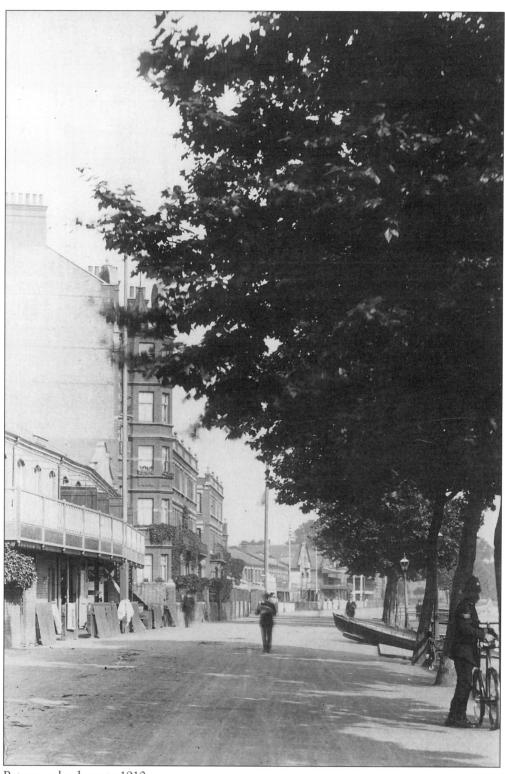

Putney embankment c1910.

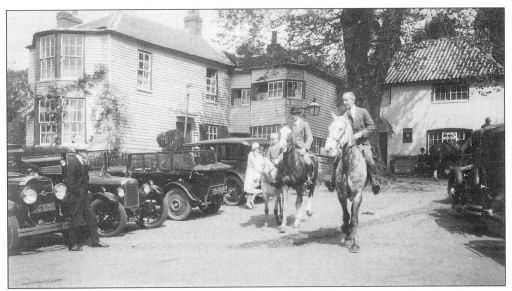

The King's Head, Roehampton c1935.

Introduction

Of all the Thames riverside towns, Putney probably deserves more than any other the suffix On-Thames.

The existence of the town is due to its position on a major route from London to the South West, a trackway which had been in use since before the Romans settled in Putney. By the time of the Domesday survey in 1086 a toll possibly from a ferry was providing a yearly income of twenty shillings to the lord of the manor. During the medieval period the ferry, fishing and farming provided the main income and public houses were built to serve the passing trade.

The sixteenth century saw many London merchants building countryside houses here and investing in the agricultural products grown locally. The increase in population and the desire of gentlemen to live in their own country villas made gradual inroads into the common lands. Development quickened with the arrival of the railway in 1846 and began to swallow up the market gardens between 1860 and 1890 when the townscape altered dramatically, the large houses in the High Street having been demolished by then. Boating came to Putney in 1845 with the University boat race and the new bridge was built in 1886.

Roehampton was home to many titled families from the early seventeenth to the beginning of the twentieth century.

Many of the larger estates in Roehampton were broken up into smaller land units and built on in the mid-nineteenth century but the village and surrounding parkland remained intact until the London County Council purchased many of the villas and grounds in 1948. As a result of wartime damage and subsequent overcrowding in London's slums the LCC built the Ashburton and Alton housing estates. The first influx of population was between 1923 and 1929 with the building of the Dover House estate. The regret is that more of the larger houses did not survive – Dover House and Ashburton House for example – but we must remain grateful for those that have: Manresa House, Mount Clare and Roehampton Houses.

These photographs show us constant changes in the fabric of the area throughout history, and the author would be pleased to hear from any person with memories, anecdotes, photographs or comments they wish to share regarding the scenes within these pages.

Born in 1947, Patrick Loobey has lived in Balham, Putney, Southfields and Streatham, all within the Borough of Wandsworth. He joined the Wandsworth Historical Society (founded 1953) in 1969 and has served on its archaeological, publishing and management committees, being chairman of the society from 1991 to 1994. Having collected Edwardian postcards of Wandsworth Borough and the surrounding districts for more than twenty years, he has a wide ranging collection (20,000 plus) encompassing many local roads and subjects.

This book will complement recent titles by the author covering the Borough of Wandsworth, i.e. *Streatham* (1993), *Battersea and Clapham* (1994), *Balham and Tooting* (1994), *Wandsworth* (1994), with second editions to follow.

Reproductions of all the views in this book are available from Patrick Loobey, 231 Mitcham Lane, Streatham, London, SW16 6PY (tel 0181 769 0072)

The captions to the photographs in this book are but a brief glimpse into the varied and complex history of the area. For those seeking further information, the Wandsworth Historical Society covers the borough's boundaries, publishing a journal and various papers, the fruits of members' research. Monthly meeting are held on the last Friday of each month at 8p.m. at the Friends' Meeting House, Wandsworth High Street.

The following books have been invaluable as sources:

K. Bailey, *Putney 1851*, Wandsworth Historical Society, 1981
G.& M. Dewe, *Fulham Bridge 1729-1886*, Fulham and Hammersmith Historical Society, 1986
C. Dunbar, *Tramways in Wandworth and Battersea*, 1971
Dorian Gerhold, *Putney & Roehampton Past*, Wandsworth Historical Society, 1994
D. Gerhold, *Putney In 1636; Nicholas Lane's Map*, Wandsworth Historical Society, 1994
P. Gerhold, *The Story of Coalecroft Road*, 1977
C.F. Lindsey, *Around Wandsworth*, 1991
P. Loobey, *Flights of Fancy*, Wandsworth Libraries, 1981
Helen Osbourne, *Inn and Around London*, Young & Co., 1991
M. Pike, *The Oak Tree*, 1960
A. Shaw and J. Mills, *We Served 1939-1945*, Wandsworth Libraries, 1989
Tim Sherwood, *Change at Clapham Junction*, Wandsworth Libraries, 1994
J. Skelly, *The Romance of the Putney Heath Telegraph*
J.M. Stratton, *Agricultural Records,*1978
M. Webb, *Amber Valley Gazeteer of Gtr London's Surburban Cinemas*, 1986
Newsletters and the *Wandsworth Historian* journal, 1956-1995, Wandsworth Historical Society

The author must thank and recommend the local history library at Lavender Hill, Battersea, where early newspapers, deeds, directories, maps and parish records are made available to those wishing to research names, dates, and addresses of families or business concerns.

One
The Riverside

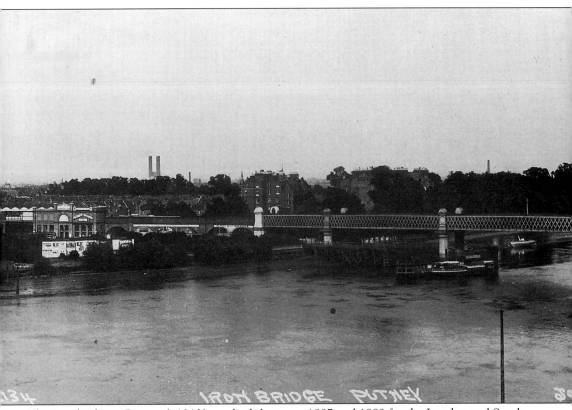

The iron bridge at Putney (c1912) was built between 1887 and 1889 for the London and South Western Railway Co., which owned the rail line from the bridge to Wimbledon. Putney Bridge station on the underground system was opened in March 1880 and called Putney Bridge and Fulham until 1902. It was renamed Putney Bridge and Hurlingham until 1932 when it gained its present name.

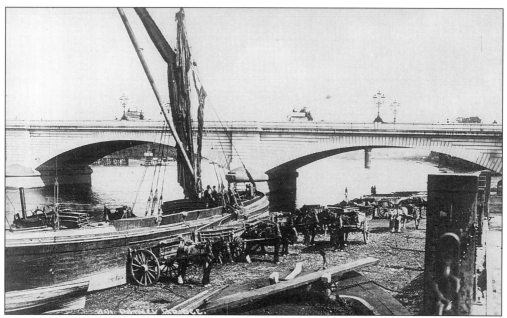

The upper view, from c1906, shows the Thames foreshore by the present bridge crowded with horses and carts unloading building materials from a sailing ship, destined for housing and retail devolopments in progress at that time in Putney. The bridge was opened in 1886 and is seen below in about 1936, three years after it was widened from 44ft to 77ft to accommodate the increasing volume of traffic.

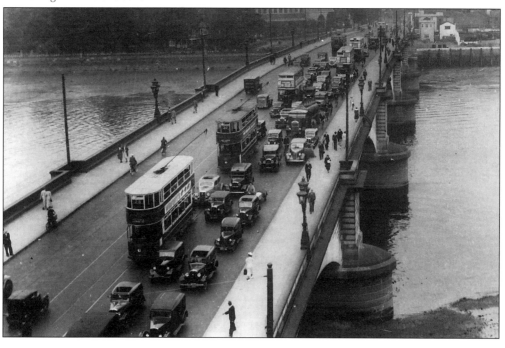

Both these riverside scenes from c1906 depict methods of transport rarely seen today. The steam tugs, with funnels lowered to clear Putney bridge at high tide and towing several barges, were a common site until the 1960s. Since then many of the riverside wharves have become disused, industry having moved away from London. The paddle steamer is en route to Kew; they were first seen on the Thames in about 1815.

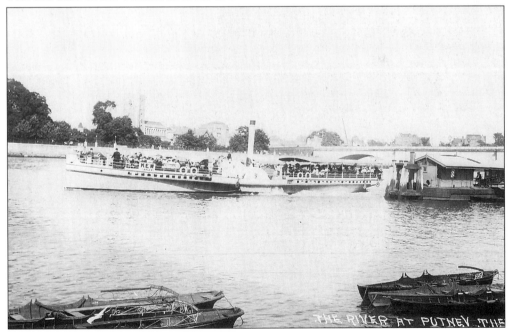

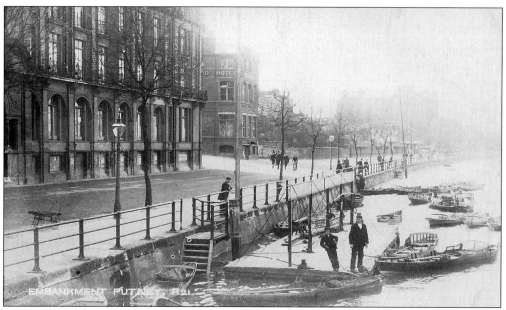

Putney embankment c1906, with the Star and Garter public house on the left. Champion's had their own pontoon moored here for hiring out skiffs which were licensed to carry six people. The two sets of stairs on the embankment, which gave access to the foreshore, were removed when the local council replaced the railings in the 1980s.

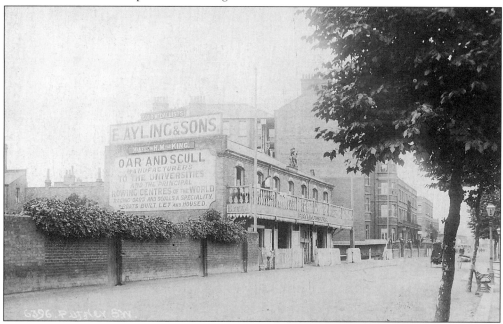

Putney embankment c1906. Before the eighteenth century river traffic at Putney would have included fishing, ferry and goods (or barge) traffic, the waterway being a major highway and free of obstruction, unlike the roads of the time. In the nineteenth century rowing gained in popularity as a sport, an increasing number of clubs and boat builders coming to Putney. Ayling & Sons, builders of oars and skulls, moved here from Vauxhall in about 1900 and continued in business up to the late 1980s, supplying for example the oars to the university crews.

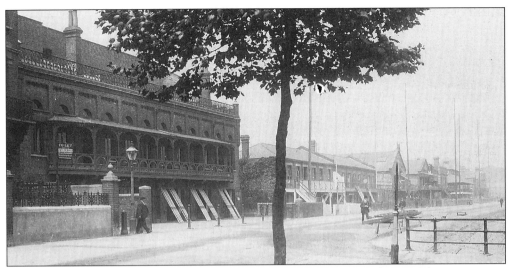

The embankment at Putney c1906. On the far left, by the street gas lamp, is the entrance to Spring Passage. The London Rowing Club building on the left was erected in 1871, the club originally using the Star and Garter as its headquarters. The club was the first to use sliding seats on their boats on the Thames in 1872. Further along can be seen the premises of Gaines Reversible Propellor Co.

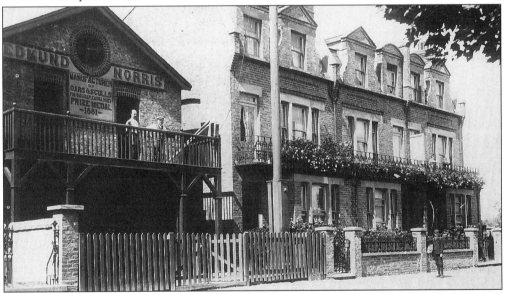

The boat builders Edmund Norris (c1906) were manufacturers of oars and skulls at Putney embankment from the late nineteenth century to the start of the Second World War. The premises were taken over by Jack Holt, whose company built clinker lifeboats, prefabricated frames for motor launches and enemy aircraft recognition models during the war. Jack Holt became well known for designing small dinghies and sailing boats, especially the 'Enterprise' and 'Mirror' class dinghies which have been built at Todmorden in Lancashire since about 1975. The company is the world's largest manufacturer of boat fittings and now use the Putney premises as an outlet called Capital Chandlers. The Star of David window at the top of the front of the building has nothing to do with Judaism but was merely a builders whim. The houses to the right are named Cliveden and Ripley.

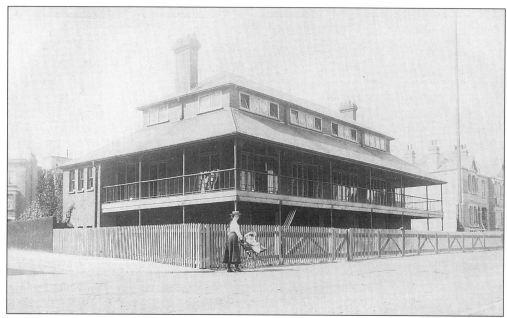

The Thames Rowing Club premises on the embankment and corner of Rotherwood Road in 1905. The building was erected in 1879, with the characteristic verandah, which is now enclosed with glass panels, very prominent. To the right has since been built the Imperial College boat club house, erected by Charles Bristow (1896-1985), founder vice president of the club.

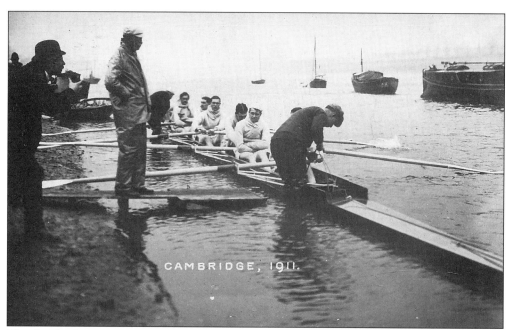

CAMBRIDGE, 1911.

The Cambridge crew at Putney in 1911 preparing for what became the third fastest time for the race; they lost to the Oxford crew, who won by two and three quarter lengths in a time of 18 minutes and 29 seconds.

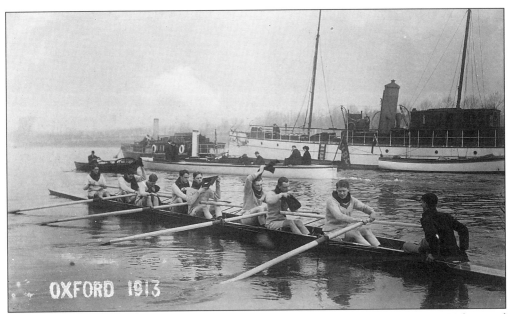

The University boat race between Oxford and Cambridge has taken place since 1829 but used the course from Putney to Mortlake since 1845, except for three occasions when it was held in the opposite direction, and during the First and Second World Wars (1915-19 and 1940-45). Up to the Second World War the embankment was a mass of crowds enjoying the fairground rides and hawkers selling either dark blue or pale blue bunting and ribbons during the two weeks before the race. The Oxford crew is seen here preparing for the 1913 race, which they won.

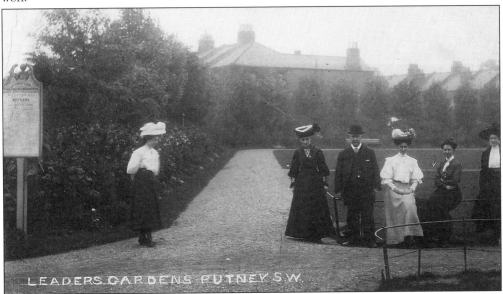

Leaders Gardens, on the embankment between Ashlone Road and Festing Road, shortly after opening on 4th July 1903. The site was given by John Temple Leader, a developer of much land in Putney who had lived on Putney Hill. The original 2 Qr acres was expanded by Wandsworth Council in 1978 by closing off the lower part of Ashlone Road after the council depot nearby was developed for housing.

15

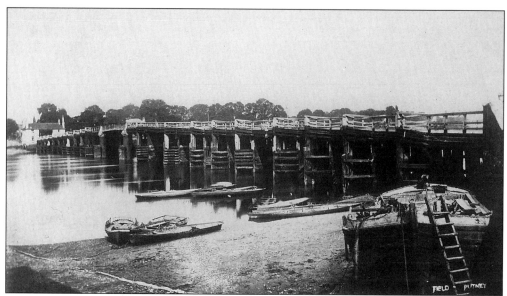

Putney old bridge was built in 1729, the first to be built between London bridge and Kingston, and managed by the Fulham Bridge Co., which collected tolls from those wishing to cross. The timber structure, which quickly became known as Putney rather than Fulham bridge, was in constant need of repair due to sinking of the piles and damage from floating ice and errant barges. The rights of the company were bought out by the Metropolitan Board of Works and the bridge freed of tolls on Saturday 26 June 1880.

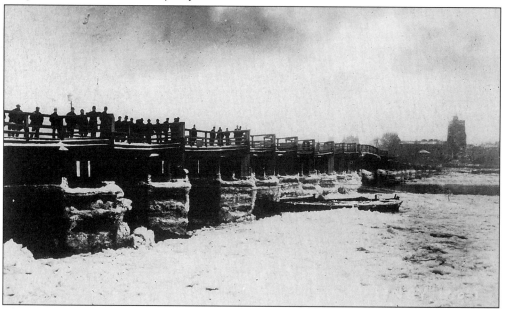

The first toll free winter for Putney bridge in 1880-1 was severe, with snow falling as early as 19th October. The worst snowstorm of the nineteenth century fell on 18-19 January, piling up into immense drifts in an easterly gale and causing many deaths. Ice floes on the Thames became blocked against the wooden piers of the bridge, threatening the structure and free passage on the river. Frosts were noted on 1 May, 9 June and 28 July and they destroyed some crops.

Two
Putney Past

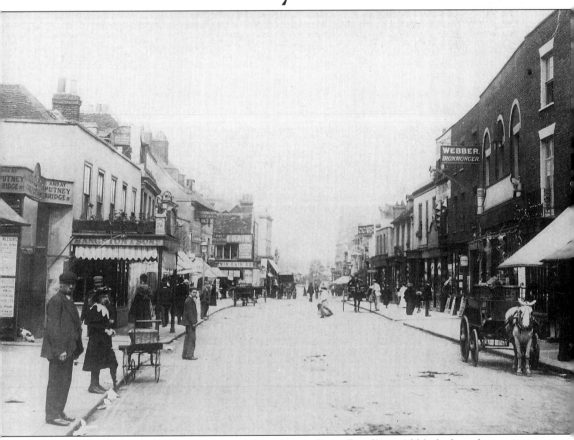

Putney High Street near Coopers Arms Lane (now Lacy Road) in 1890, before the major developments that would shortly remove nearly all of these seventeenth- and eighteenth-century shops. Webber's ironmongers, on the right, has a display of chimney pots and buckets. The canopy over the pavement on the left is that of Langston and Son, butchers, with carcasses hanging in the open air beneath.

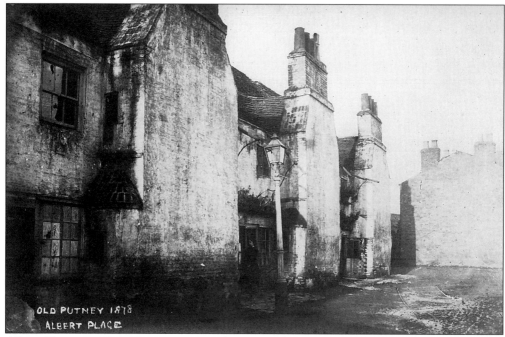

Albert Place in 1878. These seventeenth-century houses were soon to be demolished and Weimar Street now occupies the site. The eighteenth-century name for this cul-de-sac was Thundering Alley; just beyond stood the Putney workhouse from about 1726 until 1836.

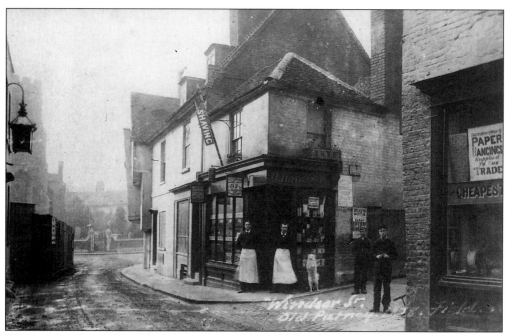

Windsor Street in 1878. When the present stone bridge was built in 1884-6 these seventeenth-century timber-framed buildings were demolished to improve the approaches to the bridge which now form part of the Lower Richmond Road. In the background on the left can be seen St Mary's parish church.

18

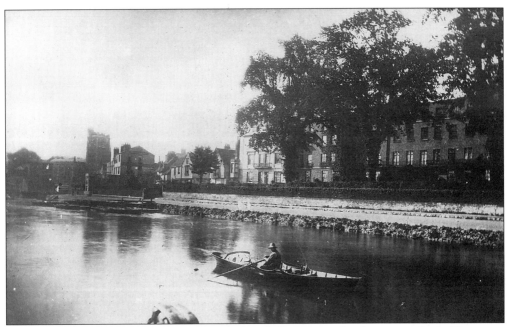

Putney riverside in 1878, some nine years before the present embankment was built. The tower of St Mary's parish church is to the left and the terrace of eighteenth-century buildings beyond the trees is now occupied by Kenilworth Court.

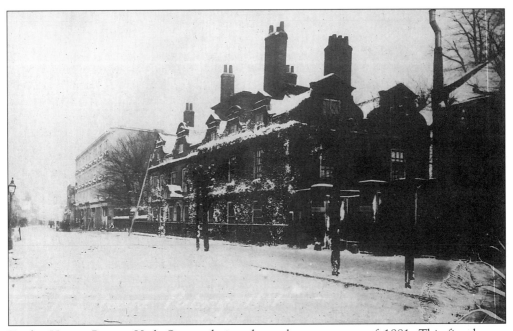

Fairfax House, Putney High Street, during the early snowstorms of 1881. This fine house, probably dating from the 1630s, was demolished in 1887 after a short-lived campaign to save it. The site is now covered partly by British Home Stores and Montserrat Road.

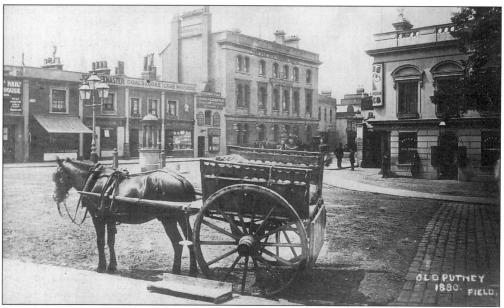

The junction of the High Street and Upper Richmond Road in 1880, with the earlier Railway public house on the right. The three-storey building is the Fox and Hounds public house, and to the left, alongside, is The Duke of Edinburgh public house. To the left, W.H. Scaldwell's cigar merchants is next to Green's jobmaster, who hired out horses and carriages.

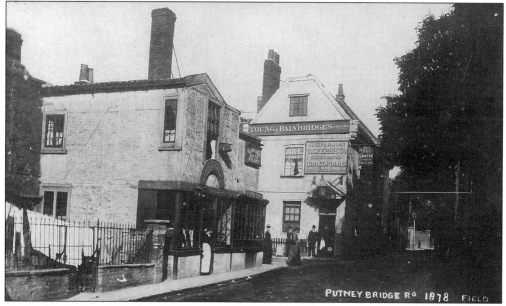

Putney Bridge Road in 1878. S. Miller, umbrella and parasol manufacturers, occupied the building in the foreground. Beyond is the original Castle public house, which dated from the 1750s. The road here was considerably widened when this pub was demolished in 1935 and rebuilt in 1936-7. This new building was destroyed in a bombing incident on 19 April 1941, when fifty-three people were killed. The pub was rebuilt in 1959, but neither Young's breweries or the Wandsworth Historical Society have a photograph of the 1937 building. If you know the whereabouts of such a view please contact the author.

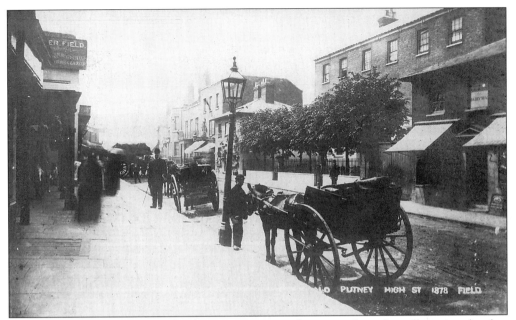

Putney High Street in 1878. The three-storey private house on the right still survives but has had single-storey shops built out in front where the trees once grew. The shops on the left were demolished and replaced by the Electric Palace cinema in 1911.

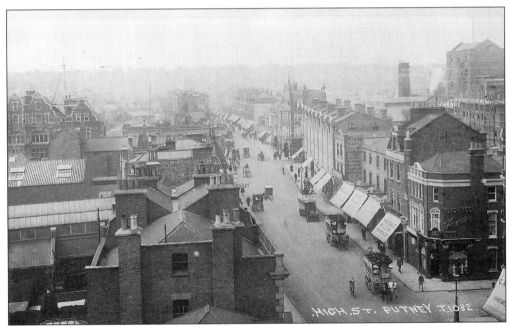

This scene, facing south from the tower of St Mary's church, shows the roofs of the eighteenth-century shops on the east side of the High Street and also the twin towers of the Putney market. The Bull and Star public house (demolished 1971) can be seen on the corner of Felsham Road. Looming on the right is the chimney and large buildings of the Mann and Crossman brewery, which closed in the 1960s. In front of the brewery, surrounded with scaffolding, is the Hippodrome theatre in course of construction.

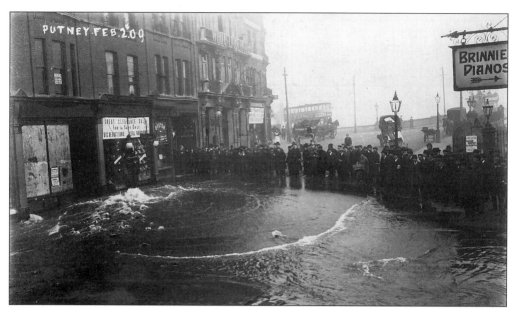

A burst water main in Putney High Street on 2 February 1909. Water is gushing from the pavement outside the premises of William Garratt's shop. They were having a '14 day clearance sale with big reductions' at the time and must have lost many customers, as must Kennally's Oyster Bar next door.

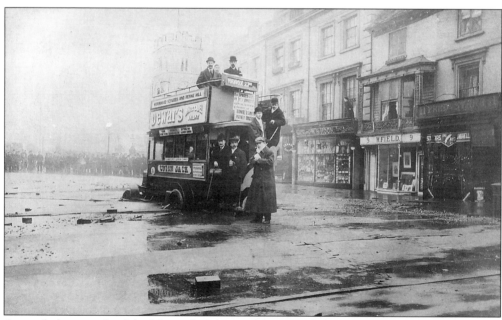

A posed photograph of the Union Jack bus and its 'stranded' passengers on 2 February 1909. The driver thought he could get through the flood, not realising the foundation of the road had been undermined, and the wooden block surface gave way leaving the vehicle sunk up to its chassis.

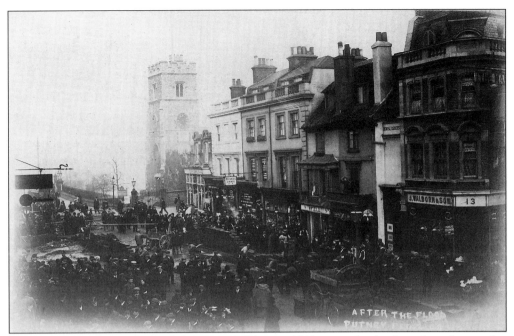

Great crowds gather in the High Street on 2 February 1909 to see the fire brigade and steam fire engine pumping out the flooded shop of Brinnies Pianos. The horse and cart on the right was a Wandsworth Borough Council unit No. 20 being used to collect the wooden blocks displaced by the flood.

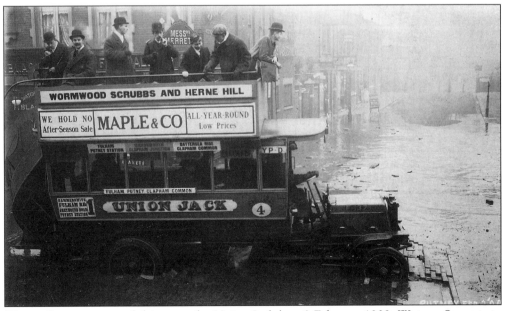

'Trapped' passengers and driver on the Union Jack bus, 2 February 1909. Weimar Street is in the background.

The High Street c1958. The tower of St Mary's church, dating from the fifteenth century, is the oldest structure in Putney and survived the 1973 fire that destroyed much of the church interior. Next to it is the London Transport bus garage, opened in 1913 for the National Steam Car Co. Ltd which was soon taken over by the London and General Omnibus Co. The garage closed in 1957 and in 1959 a sixteen-storey office block was erected. The first tenant in September 1963 was Hotpoint Ltd, followed by ICT (International Computers and Tabulators), later ICL (International Computers Ltd). The Bridge snack bar, with its glass model of a V1 'Doodlebug' in the window, was well patronized by the bus drivers, but this row of shops was demolished in about 1971.

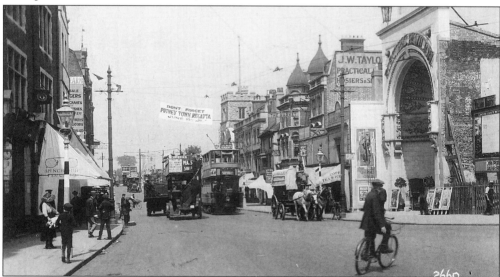

The High Street, with Putney Bridge Road to the right. The banner is for the Putney Regatta held on 19 June 1913. The twin towers of the Putney Market are to the right of the tram. The Electric Pavilion cinema on the right was erected in 1911 and underwent a number of name changes: the Blue Hall when reconstructed and extended in 1926, the Putney Theatre in 1927, the Palace up to 1955 when it was renamed the Gaumont, and finally the Odeon in 1962. The cinema closed on 11 December 1971 and was demolished shortly after.

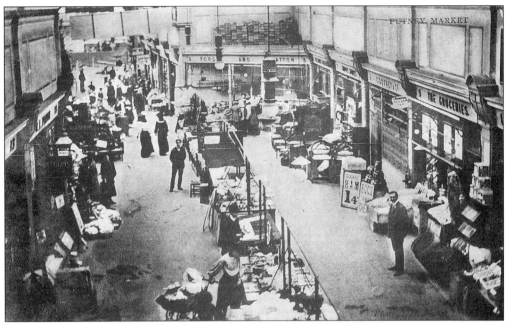

Interior of the Putney market c1906. The market fronting onto the High Street was opened on 18 May 1904 with a variety of outlets in twenty-four shops, including a butchers, fishmongers and, at No. 9 on the right, The Groceries, outside which an advertisement board advises 'Eggs are cheap'. The market was never much of a success, closing in the 1920s and demolished in the mid-1930s, being replaced by the Regal cinema which opened on 8 November 1937. There was a proposal in 1935 for the cinema to be named the Eldorado.

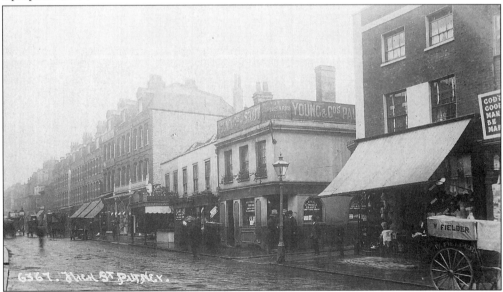

A late survival in the High Street was the Cooper's Arms public house, seen here in about 1905, which gave its name to Cooper's Arms Lane, later renamed Lacy Road. The eighteenth-century pub and cottages alongside, including Langstone's butchers (see p.17), were demolished soon afterwards and replaced by some Edwardian shops, which were removed in the late 1980s and in 1990 an entrance was built for the Putney Exchange shopping centre.

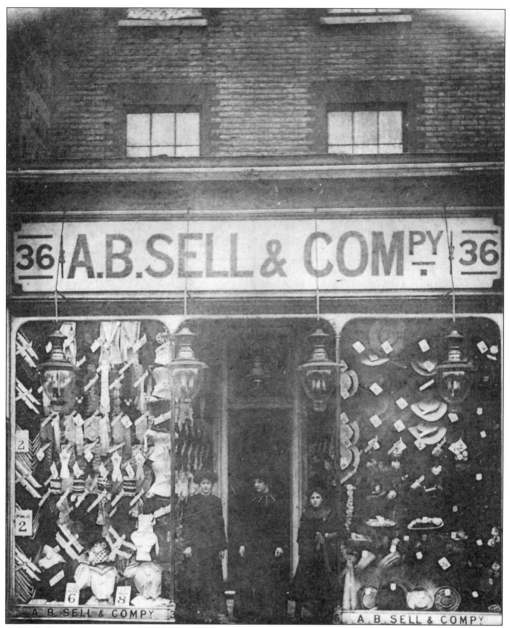

A.B. Sell and Company, 36 Putney High Street, c1904, with three young lady assistants in the doorway ready for customers to purchase from the display of ribbons and braid or from the variety of hats costing 1s 6d to 2s 11d.

Three
Putney High Street

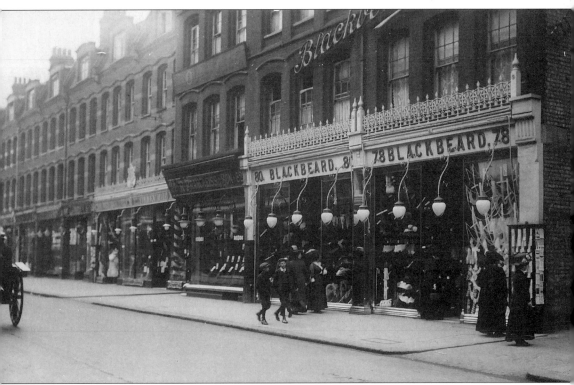

Blackbeard, milliners at 78-80 High Street (c1914), with its elegant shop front, had a wonderful display of cloth and dressmaking materials in the window. Advertisements for the store in 1911 proclaimed it 'One of the largest and best selected stocks in South London', selling fur muffs and stoles at 18s 11d, 21s 9d, and up to 50s. At No. 82 next door was Richard Franckeiss & Son, tailors and outfitters.

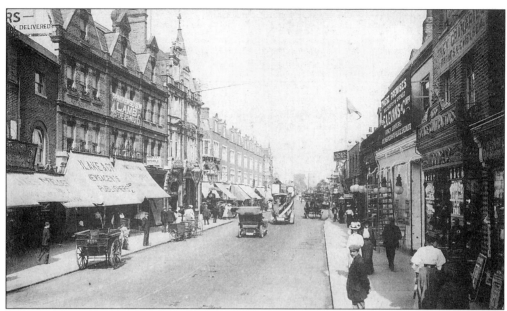

Putney High Street c1907. At the far end of the parade of shops (between Felsham Road and Lacy Road) on the left can be seen the Bull and Star public house, built in 1898, but there was a pub of that name as long ago as 1692. The pub closed on 1 August 1971 and was demolished, together with the whole parade, soon after. The butchers on the left is advertising prime new season lamb at 4 Q w d per pound for forequarters and 6d per pound for hindquarters.

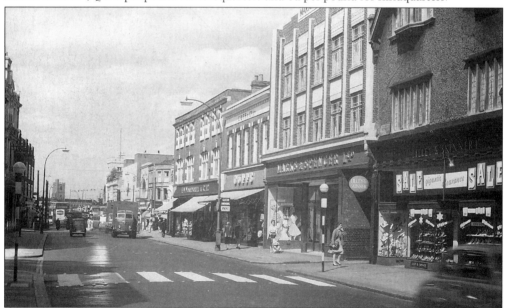

Putney High Street c1958. Near the church can be seen the Regal cinema and also the Palace cinema, with Foster Brothers clothing store occupying the corner position at Putney Bridge Road. Cullen's grocery was next to F.W. Woolworth's, and Cuff's haberdashery store (sorely missed and fondly rembered) was next to the three-storey premises of Marks and Spencer. The façade and roof line of Lilley and Skinner's shoe shop is still worth studying from the other side of the High Street.

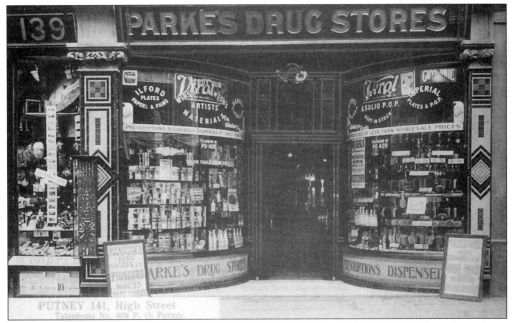

Parkes Drug Stores, 141 High Street, c1912. The company had many branches throughout London willing to collect and deliver prescriptions and supplying various branded and company made products. How many shops in Putney today would display a sign proclaiming 'Ici Parlais Francais' (French Spoken Here) as seen on this doorway?

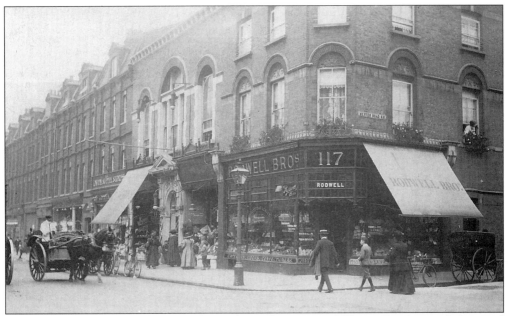

Rodwell Brothers, 117 High Street (c1912), on the corner of Werter Road, were bakers and confectioners. Above the neighbouring shop at No. 113 was the Putney Assembly Rooms, used for various meetings and concerts, but by 1911 advertised as the Princes Picture Palace and charging 2d and 3d for children and 3d and 6d for adults. The rooms now form the book department of newsagents and stationers W.H. Smith.

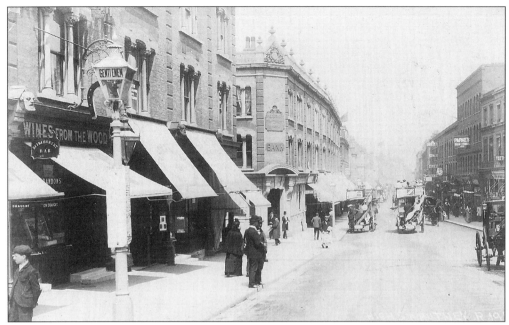

The High Street in 1905, with a bank on the corner of Norroy Road soon to be converted for use by Boots chemists. On the left behind the lamp post can be seen the distinctive sign of the Horseshoe public house, which closed in 1980. Empty for a number of years, it has recently reopened as the Rat and Parrot public house. Above the shop façade can be seen one of the many busts in the High Street of Benjamin Disraeli, Prime Minister in 1868 and 1874-1880.

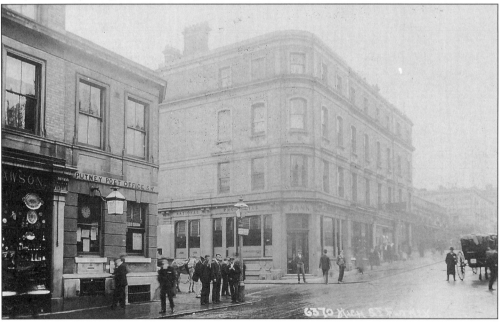

The High Street in 1905, with the National Provincial bank on the corner of Disraeli Road and, further on, Putney railway station. The post office at No. 151 first opened here in 1874 and finally closed on 15 April 1961, moving to the nearby Upper Richmond Road, the High Street premises becoming a ladies fashion shop.

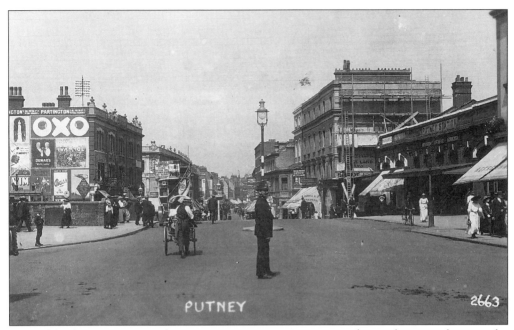

The rail bridge in Putney High Street in 1913 was yet to receive the single-storey shops on the left, built at the same time as this section of roadway was widened in the 1920s.

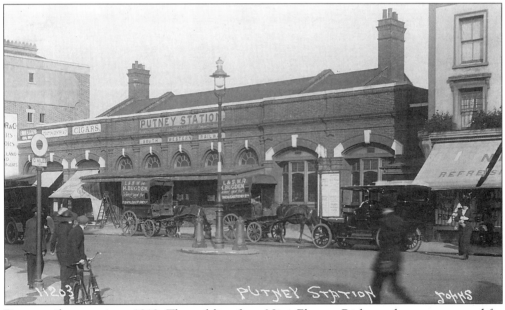

Putney railway station c1912. The rail line from Nine Elms to Richmond was constructed for the Richmond Railway Co. and opened on 27 July 1846 but was operated by the London and South Western Railway Co., which took over the RRC the following year. The 1846 station was similar in design to the surviving Barnes station. In 1886 the line was increased from two to four tracks, and in 1902 the station entrance shown here was built. The two delivery wagons of the LSWR were supplied by H. Bugben, a local jobmaster.

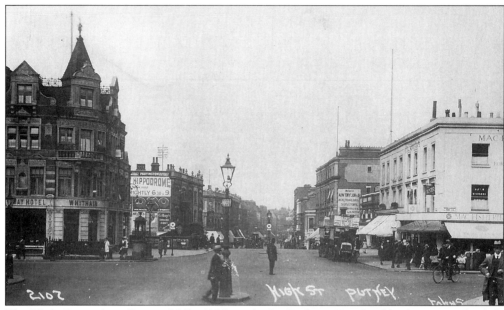

The High Street from Putney Hill c1920, with the Railway Hotel public house on the left. MacFisheries on the right moved to premises in the High Street near Chelverton Road when the whole corner was demolished and developed as Zeeta House, seen below c1950. The firm had operated in Putney from the end of the First World War, trading from premises alongside the railway station, and by 1934 had taken over several outlets, trading as confectioners and fruiterers. The management and owning company Messrs John Barker & Co. employed Mr Bernard George FRIBA as architect and Messrs Simmons Brothers built Zeeta House, which opened on 23 February 1938.

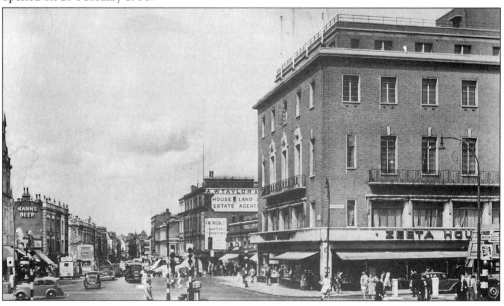

Four
Upper Richmond Road

Oakhill Court on the corner of Upper Richmond Road and Oakhill Road c1910. The block of apartments was erected about 1900 on the former site of Burlington House, in use from 1893 until 1899 as East Putney High School. The school moved to Carlton Drive and later Putney Hill, becoming in 1915 Putney High School for Girls.

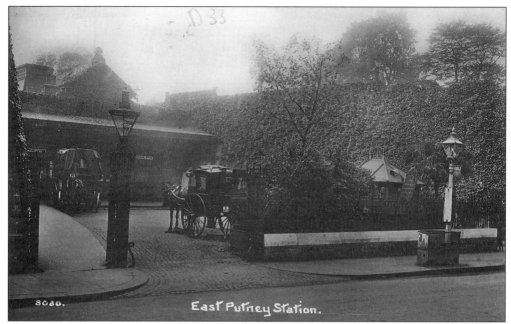

East Putney Station.

East Putney railway station (c1910) was built by the LSWR to connect Waterloo and Wimbledon as an alternative route via Clapham Junction. Accommodation was also provided to link up with the District Railway across the new rail bridge erected in 1887-9 over the Thames. The station forecourt had taxicabs waiting for those willing to pay. The line was under the ownership of the LSWR, later passing to the Southern Railway Co. and then British Railways, use of the tracks by the underground railway being paid for by leasing agreements until transfer in 1994. The snow scene is from the early 1950s.

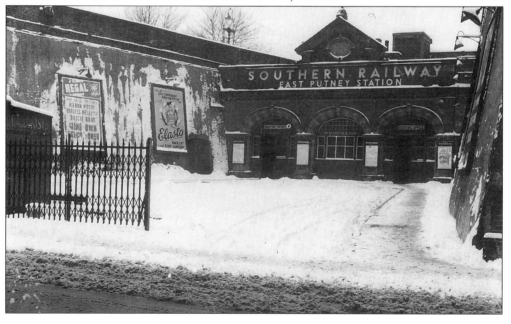

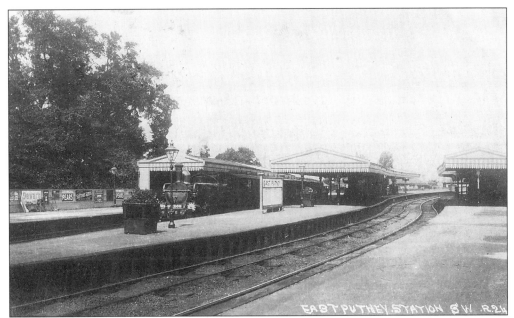

East Putney railway station in 1905 with a Wimbledon-bound District steam train at the platform. The District line was electrified the same year. On the right are the LSWR lines leading off to Wandsworth Town station. The LSWR platforms have been disused since the regular service to Wimbledon was stopped in May 1941. The lower scene, of about 1909, shows a horse-drawn bus outside the station, with a competing petrol-powered General omnibus heading towards Herne Hill in the opposite direction.

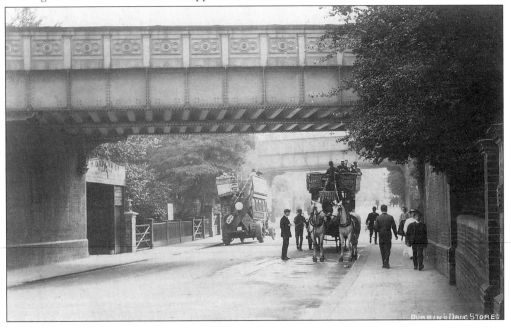

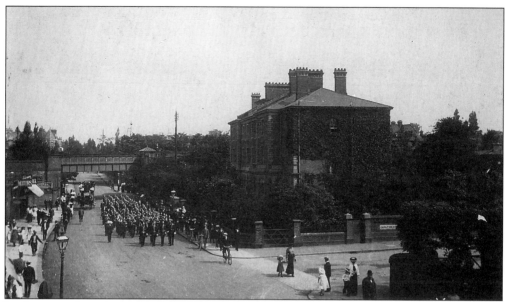

Looking east from the corner of Oxford Road in 1905-6. Carlton Road, renamed Carlton Drive in 1938, is to the right. The military band and troops marching along the Upper Richmond Road are probably from the Wandsworth Volunteers. Beyond the troops can be seen the twin bridges leading to East Putney station. The large private houses on the south side of Upper Richmond Road were demolished in the 1960s and 1970s and replaced with dull and uninteresting office blocks.

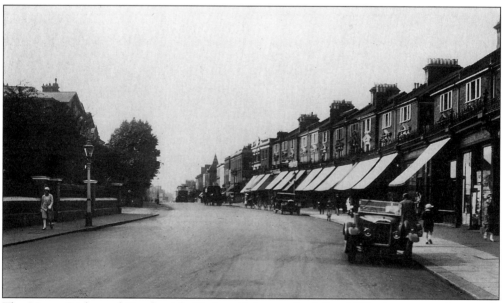

The Upper Richmond Road, with Carlton Drive to the left, c1930. A variety of privately owned shops lined the road, seen here with their blinds down to protect the goods on display from sunlight discoloration. The houses on the left had only another thirty years left before demolition.

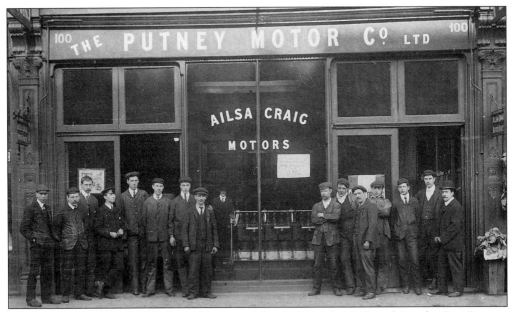

The Putney Motor Co., 100 Upper Richmond Road, formerly 17 Grand Parade, East Putney. For sale is an 8hp Daimler described as 'In working order and suitable for tradesmen'. A trial was offered of this £40 bargain. In 1891 Mr A.E.S. Craig was making bicycles in Glasgow and he was joined by a Mr Dorwald and Mr Kisch of Putney when a motorized version was decided upon. They founded the Putney Motor Co. with a factory on the Putney riverside and went on to build a series of marine engines which they fitted into various tractors, lorries and buses, exhibiting the Craig-Dorwald 'Commercial travellers' car at the 1904 Motor Show. The firm was last heard of in Wandsworth High Street manufacturing the 'Chelsea' electric car in 1922.

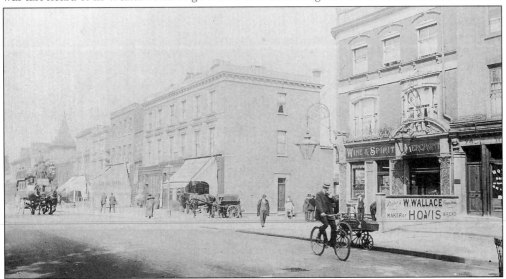

The Upper Richmond Road at the junction with Oxford Road, on the right, c1905. W. Wallace, bakers, sold bread and cakes well into the 1960s but was converted into a restaurant in the 1980s, as have many of the shops in this parade. The Prince of Wales public house has lost the massive gas lamp hanging outside but has, thankfully, retained its original name.

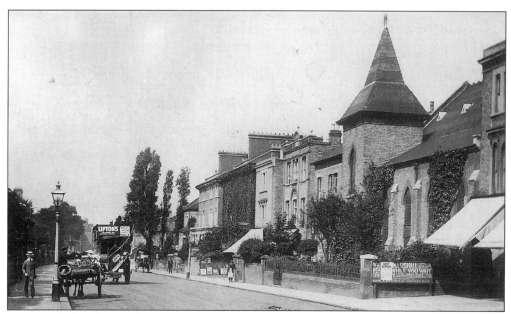

Emmanuel church, seen here c1908, was built in 1881 as a Free Church of England church and continued in use until the Second World War. The building was in use during the immediate post-war period for the distribution of orange juice, cod-liver oil and other foods for the then baby boom while rationing was still in operation. Used by a sewing machine company and for jumble sales in the 1960s, the church was demolished in the 1970s together with the private houses further along the road.

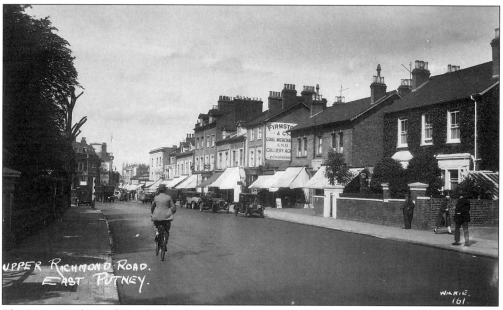

The Upper Richmond Road near the High Street c1930. The majority of these shops are now occupied by estate agents. The exceptions are the two large houses, demolished and replaced by offices in the late 1970s/early 1980s.

The offices of Frank Taylor and Nightingale, Solicitors, at 198 Upper Richmond Road. The first floor is still in use by a firm of solicitors. Note the hoarding to the left, in place while preparations are made for the construction of Zeeta House, 1936-7.

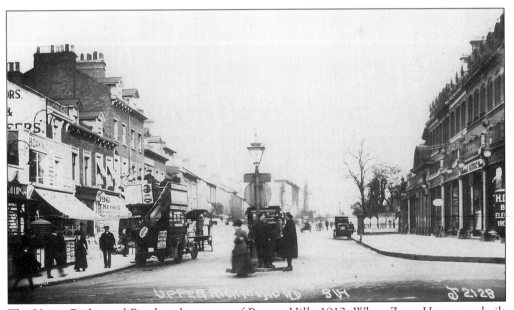

The Upper Richmond Road at the corner of Putney Hill c1912. When Zeeta House was built the small premises of H. Dakin & Co., builders merchants and ironmongers, was demolished and the kerbside and pavement was taken back to widen the road junction.

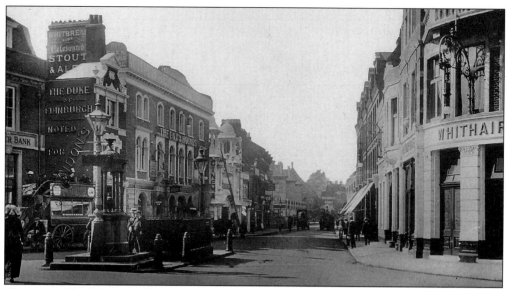

This part of the Upper Richmond Road in 1911 could be called the 'Junction of Pubs'. On the right is the Railway Hotel, renamed Flanagan's in the 1970s and later Drummond's before returning to the Railway Hotel in 1994. On the left, beyond the drinking fountain, is the Duke Of Edinburgh. Rebuilt in 1895, the pub closed in the 1970s and remained empty until recent conversion into a restaurant. The three-storey building is the Fox and Hounds; in the sixteenth and seventeenth century it was the Anchor, and by mid-Victorian times the Hare and Hounds. By the turn of the century it was the Fox and Hounds and later the Coach and Eight, but it has now reverted to the Fox and Hounds again. Further on is the Globe cinema, which opened in March 1911 as the Putney cinema. It became the Cinecenta in 1969 and finally closed on 24 December 1976. It was demolished shortly after, the threat at the time being major road widening at this junction, which never materialized.

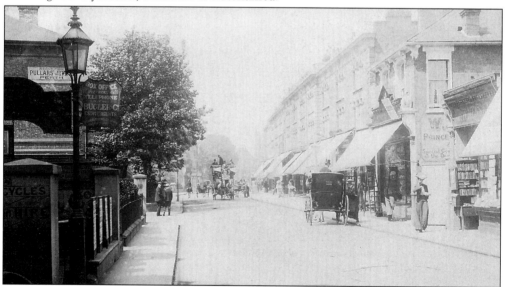

William James' Dairy on the right (c1905) still has the glazed tile dairy shop sign on the far facing wall, though it is now covered over with a hoarding. The buildings behind the trees on the left, beyond Burston Road, were not used as shops until after 1910.

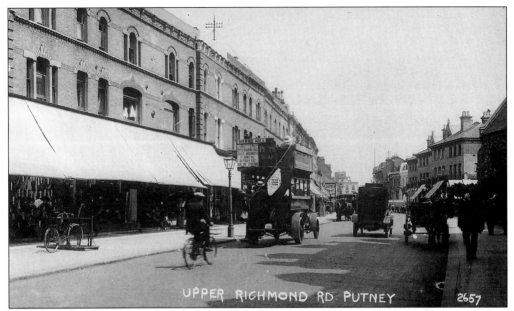

UPPER RICHMOND RD PUTNEY 2657

A No. 37 bus en route to Herne Hill (c1911) passes by the Union church on the corner of Ravenna Road. The foundation stone was laid in 1861. The church became redundant in about 1960 but found a new lease of life as a 150 seat club theatre named the Goodrich Theatre. The Unitarian church, now called Liberal Catholics, has had assembly rooms attached to the west side of the old church since it moved from East Hill in Wandsworth.

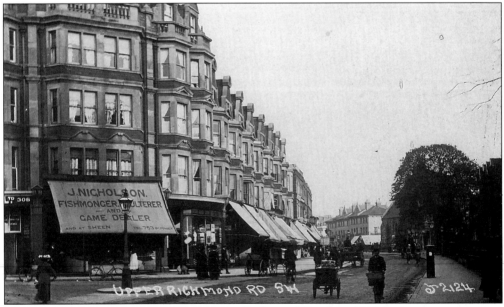

UPPER RICHMOND RD SW ST2124

The corner of Charlwood Road and Upper Richmond Road in 1912 had an imposing five-storey parade of apartments above shops like J. Nicholson's, fishmonger. The scene was altered dramatically on 18 June 1944 when a V1 flying bomb exploded here, wrecking the shops and blocking the railway line to the rear. Amongst the debris was a bus lying on its side on the roadway. Three were killed and fifteen were seriously injured. The shops were rebuilt except for the corner of Charlwood Road, which in 1996 only has some advertising hoardings in place.

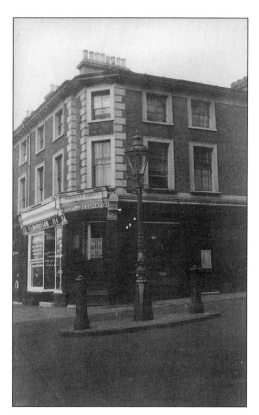

Another casualty of the V1 flying bomb incident on 18 June 1944 was Morrison's corner, so named after Morrison's dairy shop at 314 Upper Richmond Road, seen here in the late 1920s, although it was occupied by Mrs Belcher's confectioners shop throughout the rest of the 1930s. The site was left empty for forty years and a small office block erected which is now leased to Air Malta.

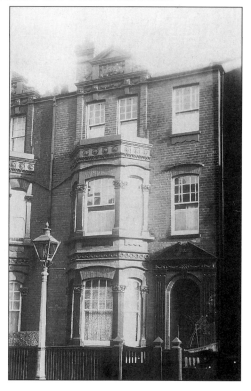

No. 1 Carmalt Gardens was built in 1886 (the date is set above the doorway) together with the neighbouring properties and adjoining houses in the Upper Richmond Road, which are almost identical but for the pediment on the roof line. Carmalt Gardens is the site of Putney House, which dated from the seventeenth century and was where, in the first half of the nineteenth century, the Revd Dr William Carmalt had his boy's school. The Royal Hospital for Incurables was based here from 1857 to 1863 before moving to West Hill, Wandsworth. The house was demolished by 1885-86.

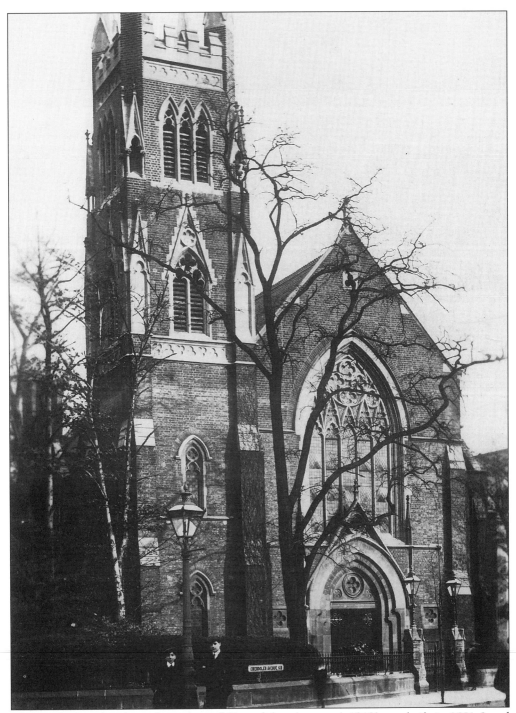

The Methodist church on the corner of Gwendolen Avenue (c1912) was built in 1881-2 and also suffered damage in the 18 June 1944 bombing incident. The church railings were removed during the Second World War and were only replaced in 1995, together with the tower pinnacles and weather vanes which had been removed about twenty years before because of storm damage and weathering.

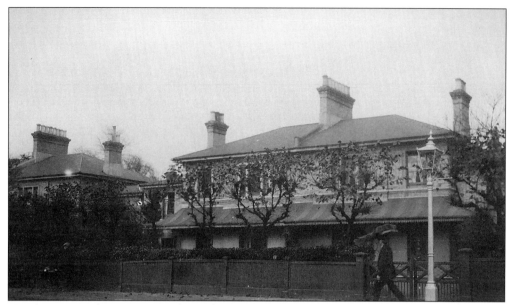

Numbers 338 and 340 Upper Richmond Road c1930. This row of houses, known as the 'Nelson' houses, were built about 1865 on Petiward family lands in ownership of the 3rd Lord Nelson's sister.

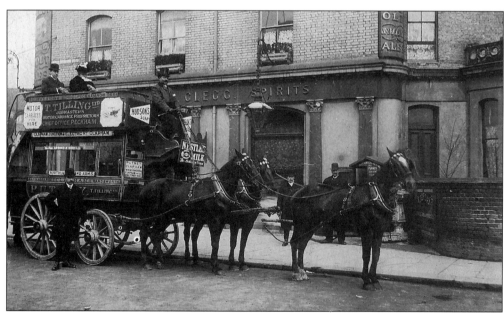

The Northumberland Arms public house on the corner of Dyers Lane (c1906) was built in the latter part of the nineteenth century. The unusual feature of the Tilling bus, en route to Clapham via Wandsworth and Battersea Rise, is the three horses required on the service, due no doubt to the number of hills encountered. On the 1636 Nicholas Lane map of Putney, there is a gate at this spot on the main road to stop animals from wandering into the arable fields.

One
Lower Richmond Road

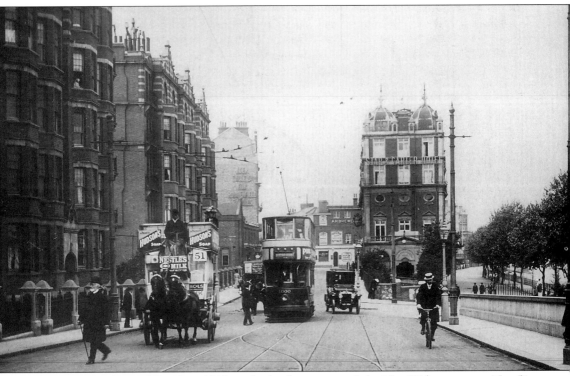

The Lower Richmond Road in 1910, with the forerunner of the No. 22 bus route: a No. 51 horse-drawn bus en route to Liverpool Street from the Cricketers public house on Putney Common. The electric tram service from Hammersmith to Putney was inaugurated on 23 January 1909 and the terminus was in front of Kenilworth Court. Electric power was supplied by overhead cables, and this terminus had an unusual automatic trolley reverser, saving the driver from manually pulling the trolley pole to the other line. Tram car No. 1000, seen here, was involved in a collision with a horse and cart on 20 December 1909 which required minor repairs to the fender.

The courtyard of Kenilworth Court c1908. Beyond the ornamental entrance is the Lower Richmond Road and All Saints' parish church in Fulham. Kenilworth Court was constructed between 1901 and 1903 with the central area laid out with flower beds, trees and also a tennis court.

University Mansions c1910, originally intended to be called Richmond Mansions when built at the turn of the nineteenth century and incorporating a parade of shops at ground level. The buildings behind the mansions were demolished in the 1960s and 1970s, and when redevelopment was near completion in the 1980s the roadway on the right named the Platt was cut in two and this northern part renamed Thames Place.

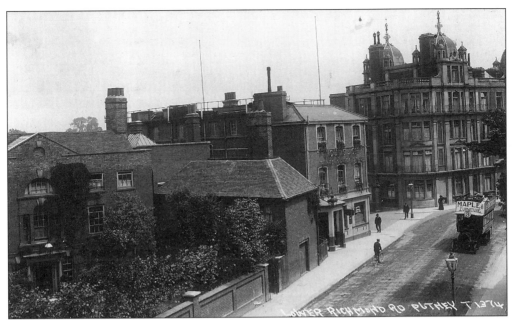

The Star and Garter public house and mansions, erected in 1900, is to the right in this view from c1906. The Duke's Head public house, first dating from the eighteenth century, was rebuilt in 1864 with further alterations in 1894. Winchester House, above left and below in about 1935, was built about 1730. The Putney Constitutional Club have been in residence since 1893-4.

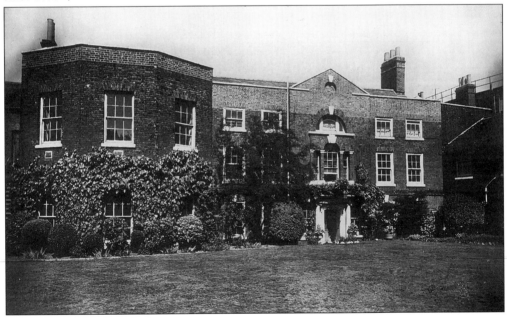

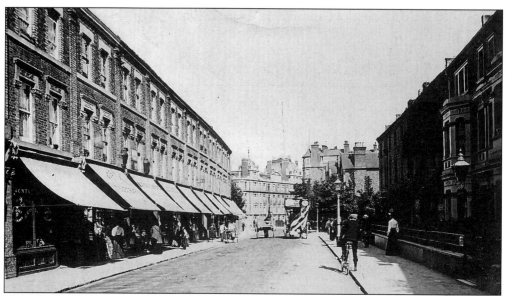

This parade of shops in the Lower Richmond Road, bounded by Ruvigny Gardens at either end, had a variety of outlets in 1907: Albert Wayman, bootmaker at No. 32; Miss E. Luttman, stationer, post & telegraph office at No. 30; and the oil jars are above the 'Oil and Color' merchants of Mrs Wakefield at No. 28. At this time only five or six basic colours of paint were available and 'Color' merchants sold a variety of coloured powders which could be mixed with the paint to produce different shades.

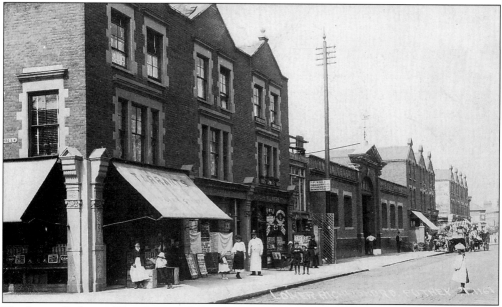

The Lower Richmond Road in 1905. On the corner of Roskell Road was Tarrant's dairy stores, and next was the newsagents and confectioners W. Pavely. The little boys standing outside W.L. Webb's confectioners shop are no doubt considering the purchase of some of the Batey ginger beer advertised. The London and General Omnibus Co. used the large building in the row as stables. The site was in use as a furniture warehouse called Times Furnishing until demolition about 1992.

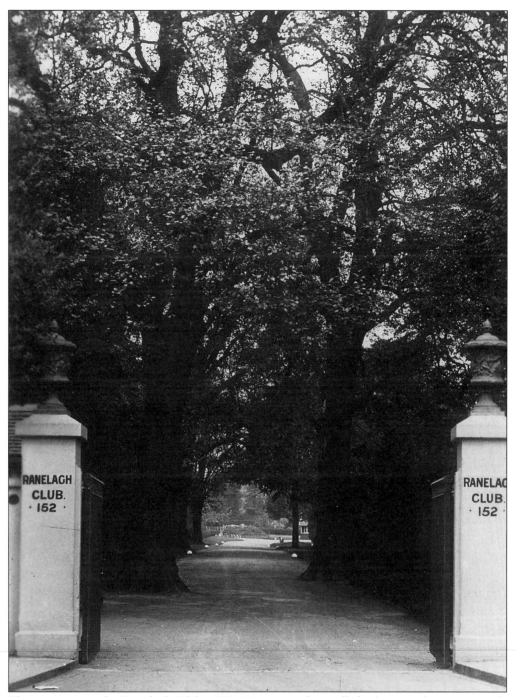

The entrance to the Ranelagh Club c1914. Many people recall the horse and carriages, with their important passengers aboard, passing through this gateway in the Lower Richmond Road that led to Barn Elms House. The house was in use by the Ranelagh Club from 1884 to 1939. Left derelict, it was destroyed by fire in 1954. The author, together with a large crowd of inquisitive onlookers, viewed the sad remains the following day. The carriageway is now a pedestrian entrance to a council housing estate built in 1952.

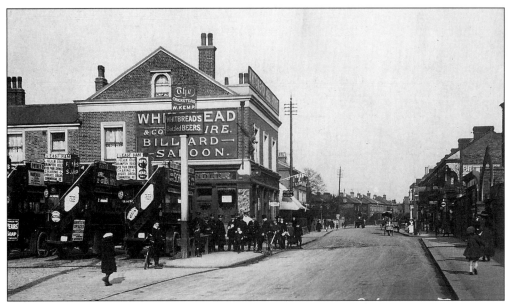

The Cricketers public house in 1912 was evidently the terminus for the buses, unlike today when a turning point by All Saints' school and All Saints' church is used. The pub gets its name from the cricket ground on the common, used as such since the beginning of the nineteenth century. The Putney Cricket Club was founded in 1870 as the St John's Cricket Club and renamed in 1890. Sir Jack Hobbs, appearing for England and Surrey, played for the club in 1904 and Jim Laker, a Surrey and England batsman, was elected a member in 1959. The pub was renamed the French Revolution in the 1970s but has recently got its name back, though in the singular, the Cricketer.

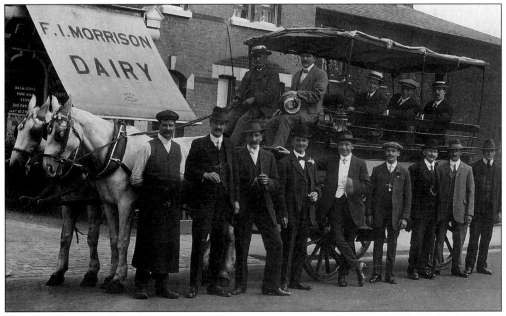

A group of men in their Sunday best ready for a summer charabanc outing about 1912. In the background is Morrison's Springfield Dairy on Lower Common. Nearby formerly was the farm where cows were kept and fresh milk supplied to various outlets in Putney.

West Lodge and Elm Lodge, Putney Common, c1906. West Lodge in 1845 was the home of Douglas Jerrold, writer and humorist. Producing at least sixty plays, his favourite work was submitting a regular article for *Punch* magazine. He entertained here many of the day's literary greats, including Charles Dickens. The site of Elm Lodge and West Lodge was chosen for the new Putney hospital. The need for a hospital to cover the ever-increasing population was felt at the end of the nineteenth century and £75,000 was donated by Sir Henry Chester towards the building fund. The land was donated by Sir William Lancaster and the hospital, seen below shortly after opening, opened in 1912.

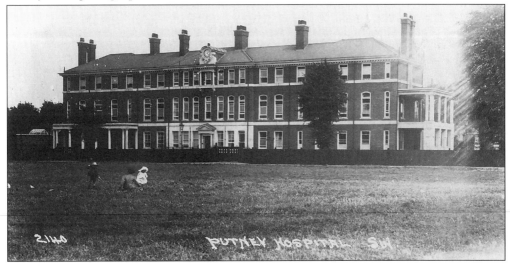

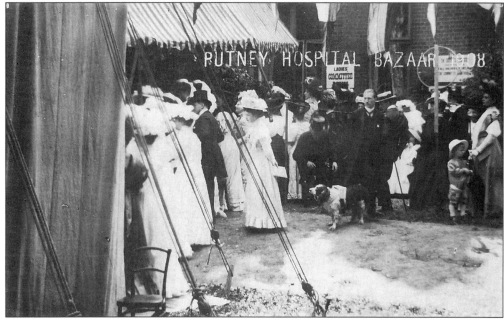

Putney hospital bazaar, 1908. To assist in collecting funds, a three day bazaar was held at Homefield, 37 Putney Hill, on 24, 25 and 26 June. The fete was opened on the Wednesday by the Duchess of Albany, with Sir William Lancaster and Sir Henry Kimber in attendance. The Duchess made a point of purchasing an article from each of the twenty-five stalls in the main marquee, which was lit with fairy lights in the evening, accompanied by the Band of the Lifeguards. The Duchess of Marlborough opened events on the Thursday and the Mayoress of Wandsworth, Mrs J.W. Lorden, on Friday, with the Mayor Alderman Lorden as chairman. In the upper view is Miss Plowright's collecting dog, which proved a great success, and in the view below the men are wearing ladies' hats, which the ladies appear to find amusing.

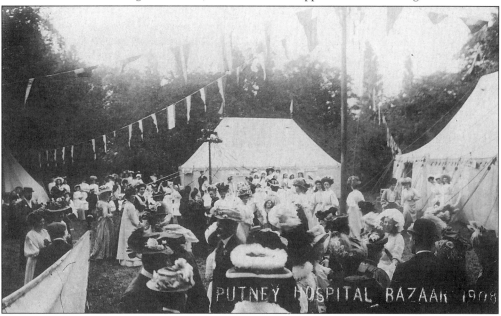

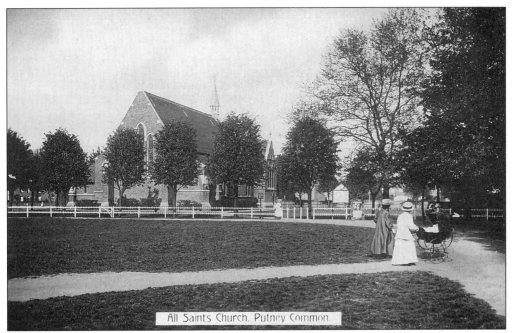

All Saints' church, Putney Common, c1910. The foundation stone was laid on 22 April 1873 by Queen Victoria's daughter, HRH Princess Christian of Schleswig-Holstein (formerly Princess Helena), and opened for services on 25 April 1874. The church has a painted ceiling of flowers and various coats of arms. Stained glass windows by Burne-Jones and William Morris installed between 1878 and 1928 are the treasures of the church.

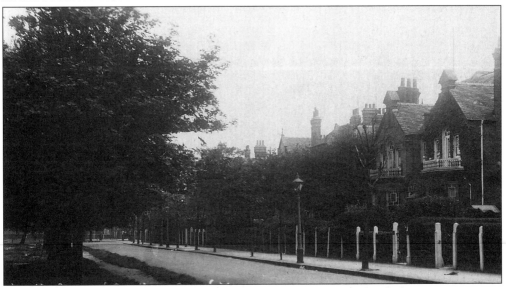

Lower Common South c1924. The former market gardens and farmland of Mr Morrison were covered by these houses in an eight-year period, commencing with several properties at the Dyers Lane end in 1883. A large detached house at No. 12 with a plaque gives the date as 1885; this was built by a Mr John Davis of Gypsy Lane nearby. Names of the houses were impressive: Fordham, Onslow, Ellerton, Roselea, St Audries, Etrick, St Andrews, Morland, Fordham Villa, Horatio Wolseley Villas, and others.

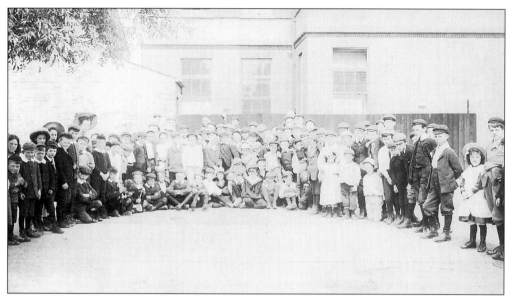

All Saints' school pupils in 1907. The school, facing Lower Common and All Saints' church, was founded for 100 infants in 1857 by the local parish as an expansion of school facilities made necessary by the population growth.

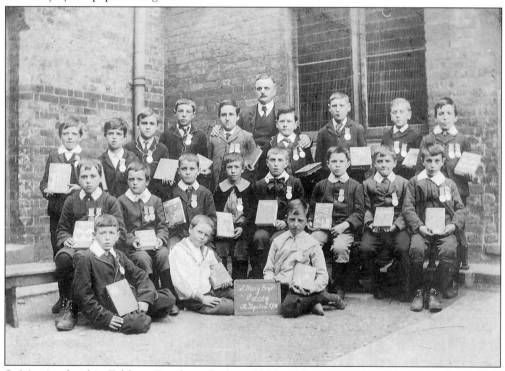

St Mary's school in Felsham Road was built in 1867, and survives. An earlier school was built on this site on land acquired by the parish in 1819. The small chalked board announces 'St Mary Boys, Putney, The Regulars 1904'. The pupils are all wearing a school or prize badge and each is holding a prize volume. The writer of this postcard has added, rather uncharitably, 'Don't they look a lot of wrecks?'

Six
Putney Hill

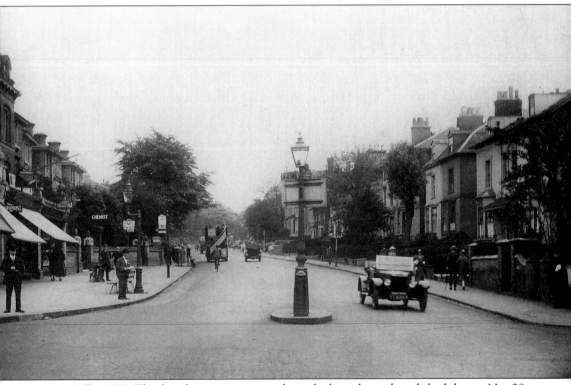

Putney Hill c1930. The first few properties on the right have been demolished, but at No. 28, on the front of the building, is a rare survivor of a fire insurance plaque, of the Sun Insurance Co. Before the houses on the left were built, an eighteenth-century mansion called Lime Grove stood here. This is where Edward Gibbon was born on 29 April 1737. He spent his childhood in Putney and later wrote *The History of the Decline and Fall of the Roman Empire*.

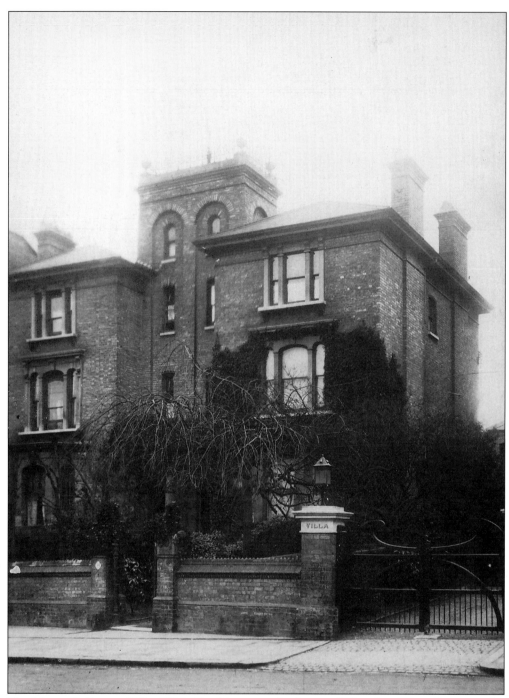

The Limes, 11 Putney Hill, c1930. The Limes was the home of Theodore Watts Dunton, who took in as a resident his friend the poet Charles Swinburne, who lived here from 1879 until his death in 1909. He was often seen strolling up the hill to the Rose and Crown public house in Wimbledon and relaxing within a private room where his favourite chair still resides. The Limes has a blue plaque to Swinburne's memory and has also managed to retain the original cast iron gate.

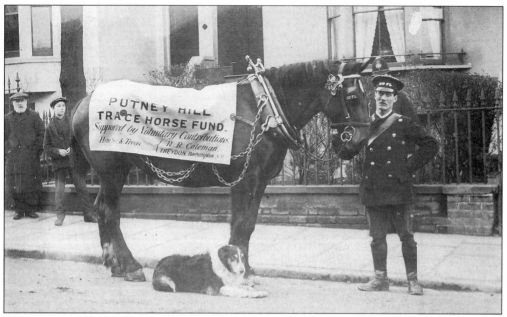

The Putney Hill trace horse, shortly after its introduction in January 1912, at the lower west side of the hill. A charitable group called Our Dumb Friends League supplied the horse and guide, charging 6d for each load assisted up the hill. The league also stationed a trace horse on Wimbledon Hill who was affectionately named 'Jack'. The honorary secretary was Mr R.R. Coleman, of Theydon House, Nepean Street, Roehampton.

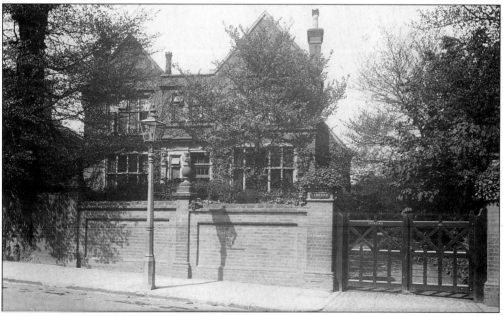

Dereham, 40 Putney Hill, c1909. This property, second house down from Cambalt Road, was part of the development of Putney Hill of the 1880s, but, like so many others, was demolished when the original 99-year leases ran out. The site is now occupied by a five-storey block of flats.

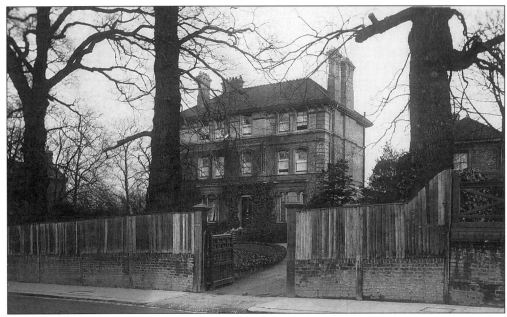

The Elms, 41 Putney Hill (c1925), another house erected in the 1860s, and one of the first to be built on the Lime Grove estate, like Dereham and so many others on Putney Hill, has been demolished. It was the second house up from Lytton Grove. The house and grounds would have been difficult to maintain and the site was seen as having valuable development potential.

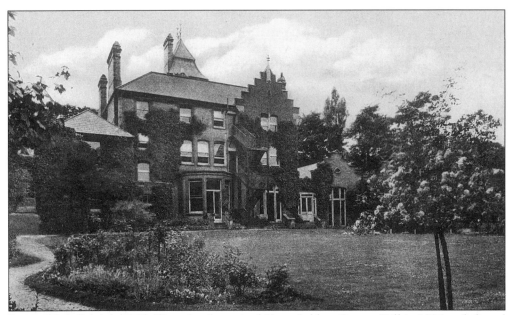

Putney High School c1920. The school acquired Homefield on Putney Hill in 1906 and altered it to become the new junior school in 1910. Lytton House nearby, with the large tower, on the Lytton Grove side was previously used as a boarding school run by Miss Elsie Hinton Smith. Putney High School acquired the lease in 1918 and converted the building into its junior school, which use it has retained. The freehold was eventually bought in 1959.

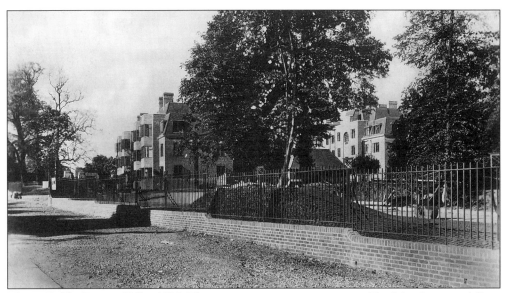

Manor Fields, Putney Hill, c1933. This private estate was constructed by John Laing and Sons Ltd in 1932-33, with 220 flats in thirteen separate blocks. The grounds are well planted with trees and shrubs.

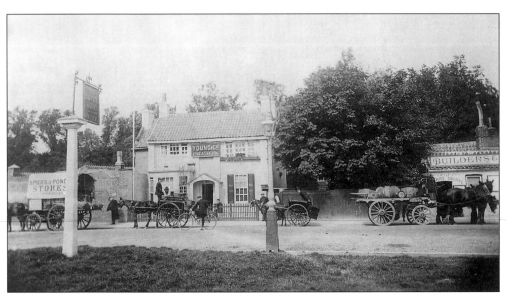

The Green Man public house, Putney Hill, c1912. The main structure is probably of the eighteenth century, and the earliest recorded date for a pub on this site is 1706. Another of the gates stood nearby in 1636 to stop animals on the heath from straying into the arable crops off Putney Hill. The cart on the right is one of Young and Co. brewery's delivery drays.

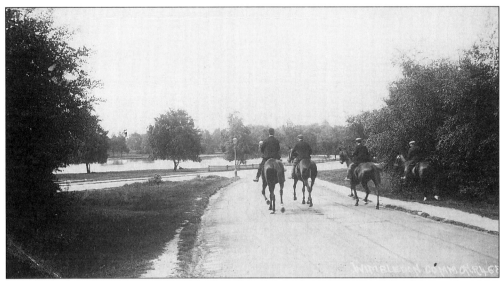

The three horsemen are riding along Wildcroft Road towards the Kingston Road c1906. Kingsmere pond is in the background. This part of Wildcroft Road was closed and grassed over to recompense the Wimbledon and Putney Commons Conservators for land lost when Tibbet's corner underpass was constructed in 1969-70.

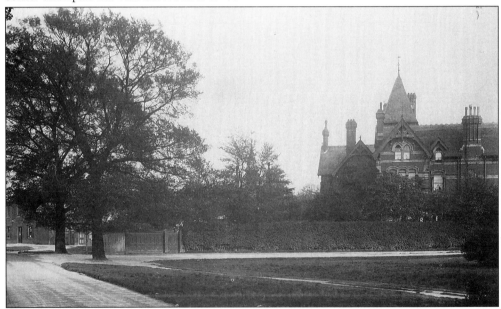

Wildcroft, Putney Heath, c1906. The house was built on almost the same site as Mr Hartley's 'Fireproof house', erected in 1776 with iron and copper plates inserted between the floors and tested with George III and guests dining above a raging fire. The house was substantially altered and extended about 1817 into a 'Tasteful Mansion'. This was bought by Sir George Newnes in 1885, who became wealthy with publication of magazines including *Titbits*; he also donated the public library in Disraeli Road. He demolished the house about 1899-1900 and erected Wildcroft, as seen above. This house was demolished in 1934 and a private block of flats named Wildcroft Manor erected in 1936. To the left is the Telegraph public house, named after the Admiralty signalling semaphore station that stood here from 1796 to 1847.

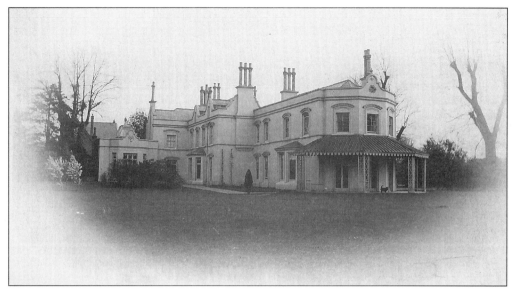

Bowling Green House, Putney Heath, c1912. A bowling green was in use on the heath from at least 1636 until 1770, at which time this house was converted into a private residence. William Pitt the younger, Prime Minister from 1783 to 1801 and 1804 to 1806, lived here for a short while and died here on 23 January 1806 aged 47. The house was demolished in the early 1930s and is covered over by Bowling Green Close.

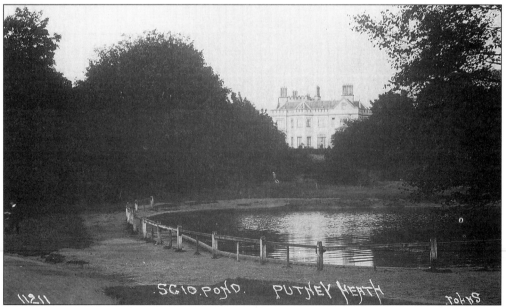

Scio House and Scio pond in 1912. This Gothic villa, dating from 1842, was named after the Greek island of Scios, the birthplace of an early resident. The house, used as a hospital and convalescent home for wounded officers during the First World War, was demolished in 1988 and replaced by a development of private flats named Lynden Gate. The roadway is the old Portsmouth road, grassed over since the Tibbets corner underpass was completed in 1970.

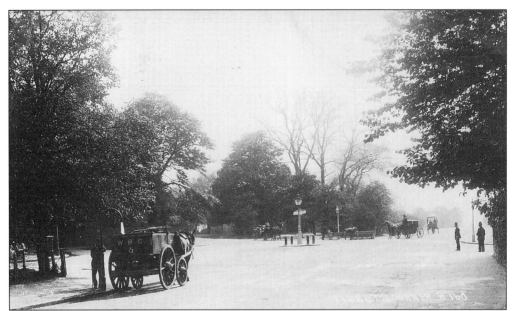

Tibbets corner c1906. A Wandsworth Borough Council employee, with water cart number 5, is filling up from a kerbside pump before spraying the dusty summertime roads. The Kingston Road is where the horse and carts are, and Putney Hill is to the right of the two policemen. The heath was certainly frequented by highwaymen, but none were called Tibbet, although a Mr Tebbit lived in one of the gate lodges here. The highwayman sign at Tibbets corner was erected in 1936 to the designs of Mr L. Hoare of Fulham, a student at the Putney School of Art in Oxford Road. In 1969-70 this scene was transformed with the construction of the four-lane Tibbets underpass at an estimated cost of £1,970,000.

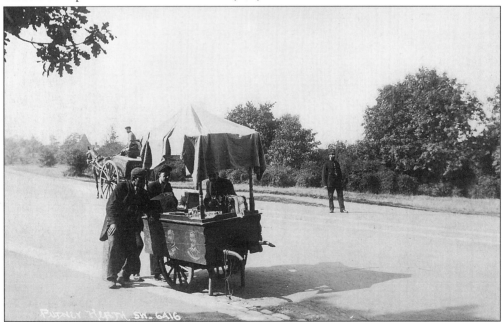

Two young boys in 1906, with their hand-pushed barrow on the Kingston Road not far from Tibbets corner, are selling ice cream and ginger beer.

One
Putney Streets

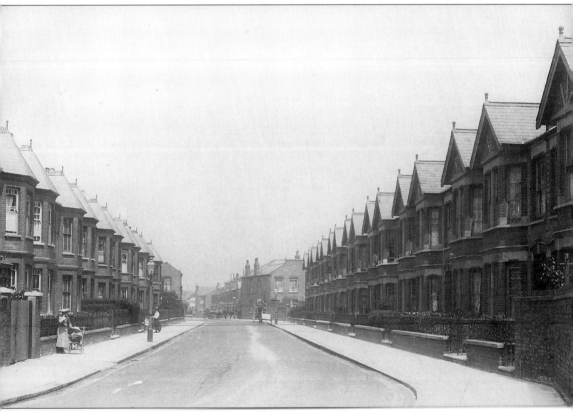

Abbotstone Road c1906. The LCC approved the road name in 1893. An interesting development took place here: the first application in 1900 was for all of the properties on the west side, which was followed in 1901 with another application for all those on the east side.

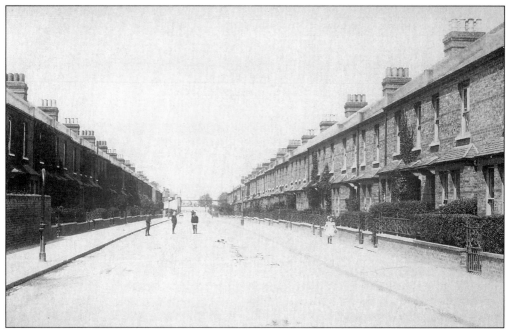

Ashlone Road c1906. The works depot for the local council, at the northern end of the road and fronting onto Beverley Brook creek, continued in use up to the early 1970s, when a housing development was built on the site. The LCC approved the road name in 1887. The planning applications for this road in 1893 was for only five houses to be built; thirty more were planned for 1894 and there was a final flourish to erect the rest in 1896.

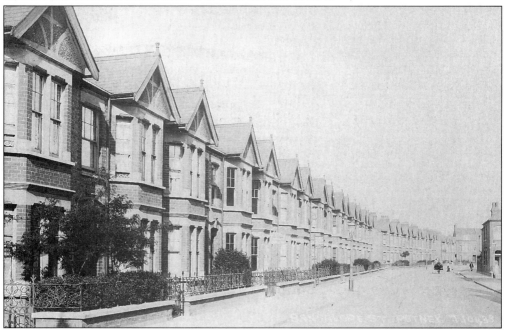

Bangalore Road c1906. The LCC approved the road name in 1898. Another late development for Putney were proposals to erect twenty-seven houses in 1901 and a further twenty-seven the following year in this road.

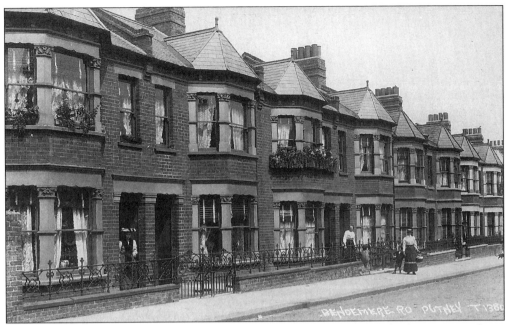

Bendemere Road c1906. The LCC approved the road name in 1893. The lower scene shows two little children standing in the middle of the road at the far end. The properties here were erected in quick succession, twenty-five planned for 1895, twenty-five in 1896, and a further eighteen in 1897.

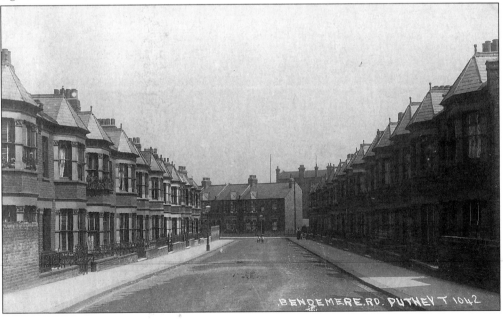

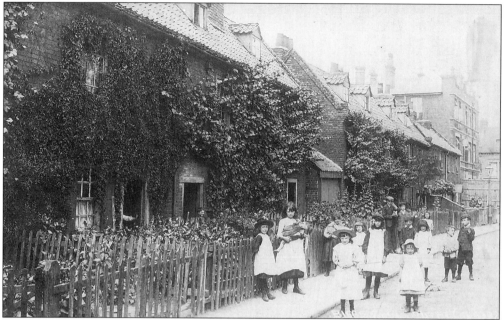

Biggs Row c1906. This row of eighteenth-century cottages to the rear of the Half Moon public house, seen in the background, was demolished and replaced in 1936 by the Henry Jackson housing estate built by Wandsworth Council. A large Irish community settled here in the first half of the nineteenth century, possibly as a result of the potato famine of the 1840s. William Biggs was a Putney landowner.

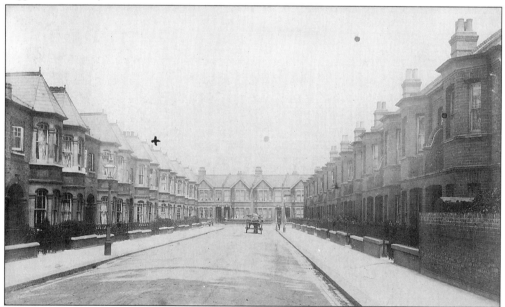

Blackett Street c1906. The area around the Lower Richmond Road at the turn of the century must have known noisy and dirt-strewn thoroughfares with the quantity of bricks, timber, plaster and associated materials brought into the adjoining roads as they were being infilled with housing. For instance, the proposals for Blackett Street were for thirteen houses in 1898, thirteen more in 1902 and twenty-seven more in 1902.

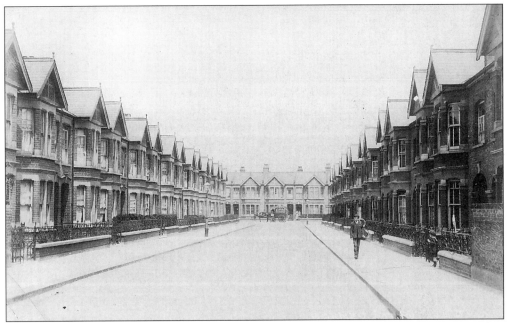

Borneo Street c1906. The reason for naming this road will probably never be known unless someone turns up some information to suggest that the developer had investments in East Asia? A personal name can be discounted. The fields were built upon reasonably quickly here, fourteen houses proposed for 1898, fifteen in 1900 and the last fifteen in 1901.

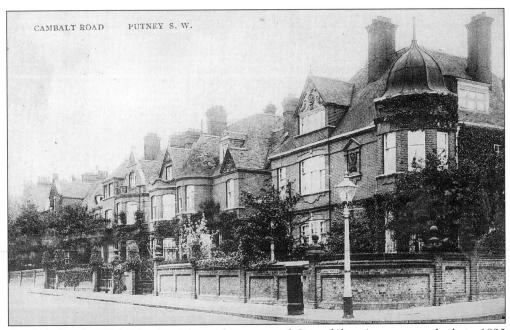

Cambalt Road c1906. Number 24, on the corner of Gwendolen Avenue, was built in 1890 following the laying out of the Putney Hill Park Estate in 1883. This house and a few on the south side of Cambalt Road survive but all of those on the north side were demolished in the 1970s and replaced with small blocks of flats.

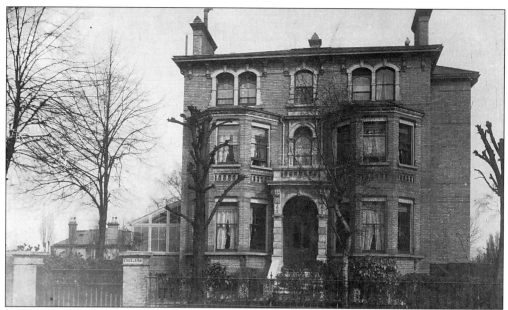

No. 36 Carlton Drive c1909. The road name was approved in 1867 and the building of these large houses on the former Lime Grove estate soon followed. The London County Council altered the name from Carlton Road to Carlton Drive in March 1938. Few of these large houses remain, the majority being demolished in the 1960s.

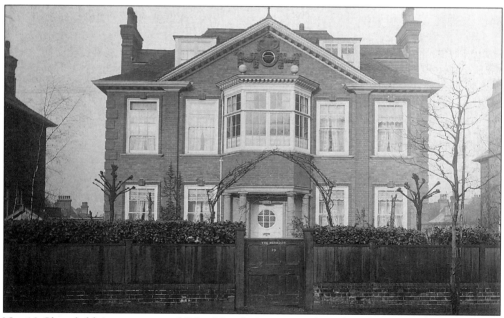

No. 19 Chartfield Avenue, named 'The Mirador' in 1912 when this photograph was taken, has since been renamed Lochaber House. The eastern end of the road, together with Cambalt Road, was developed from 1883 as part of the Putney Hill Park estate. The western part of the avenue beyond Gwendolen Avenue, i.e. where The Mirador stands, was not built until 1905-6.

Mr William Pearce Kernot is standing by the gate of 'Posilipo', 50 Charlwood Road, in December 1908. Although a few properties had existed here before the arrival of the railway service in 1846, some of the early developments that took place in 1849 were on former market gardens owned in the 1750s by William Charlwood.

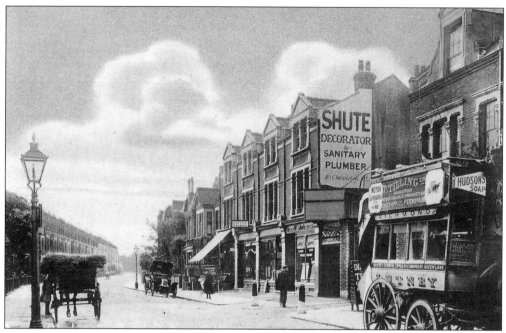

Chelverton Road c1906. The road was built up from 1887 onwards and soon acquired the bus garage and stables for the London and General Omnibus Co., the entrance to which was alongside W. Shute's builders and decoraters shop. The garage has been rebuilt and enlarged several times since. In the lower scene is a horse-drawn bus, probably en route to Richmond via Barnes and East Sheen.

Clarendon Drive c1906, originally called Clarendon Road and renamed in November 1937. The eastern part, near the Quill public house, was developed in the 1840s, and the western end in the 1890s. The author spent his early learning years from 1953 to 1959 at Our Lady of Victories RC school, founded 1925, on the corner of Charlwood Road, and, for his speech impediment, many an afternoon at the council health centre opposite founded by Eileen Lecky and Ann Gibbs in 1931.

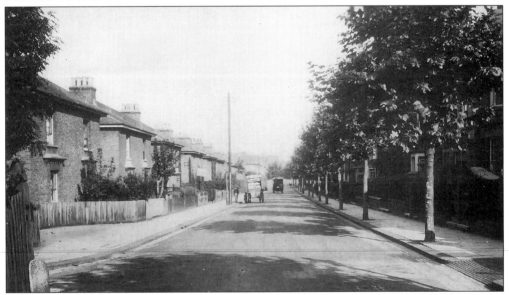

Coalecroft Road c1930. Henry Scarth commenced his building activities in the Upper Richmond Road in 1846 with some cottages and a public house named the Arab Boy after a servant boy of his. Development continued southwards along Parkfields, and what was called Upper Parkfields appeared in 1854. Formerly called Vinegar Hill and comprising four small cottages, expansion continued, the eastern side was built after 1904, and the name was changed to Coalecroft Road on Guy Fawkes Day 1935.

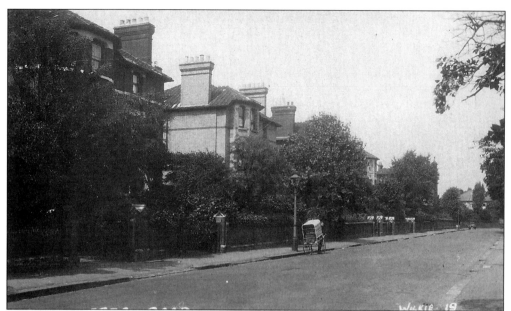

Colinette Road c1930. The land was well stocked with fruit trees when purchased by John Temple Leader for development in 1876. The road was originally called Leaders Road and then Leaders Gardens, but was renamed when the riverside Leaders Gardens opened in 1903. The road was laid out in 1878 and these substantial three-storey houses were soon built. They were offered for sale with eight bedrooms, hot and cold running water, separate cellars for coal and wine, a basement kitchen and housemaids room.

Danemere Street c1906. The LCC approved the road name in 1898. The first building proposals were for nearly all of these houses to be erected in 1891 but a few more followed in 1899 and 1900. In 1904 came a proposal to build a factory and offices at number 38, followed the next year for some open sheds and stables. Two cottages on the west side in 1909 made up the last major building plans.

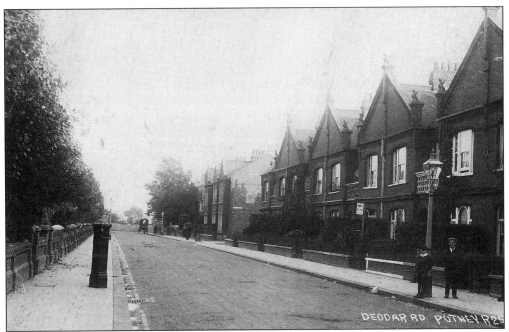

Deodar Road c1906, facing east in the top view and west in the lower. The houses were built throughout the 1890s on the former site of the Cedars, built in 1853 as a prestigious development of thirty-four five-storey houses facing the river. The scheme was never a success and became difficult to let after the District Railway cut through the road in 1887-9, and they were demolished soon afterwards.

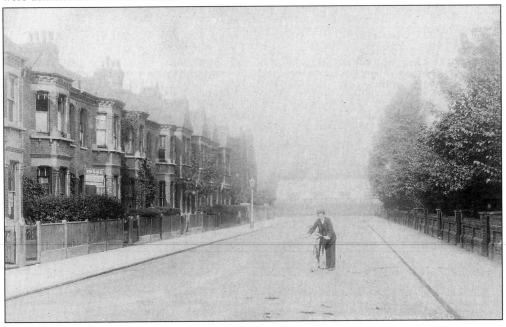

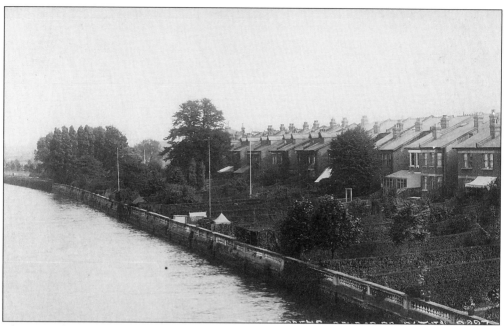

The riverside gardens of Deodar Road in 1906 still had in place the old balustrade wall from the previous Cedars development. A few of these balusters survive as garden curiosities.

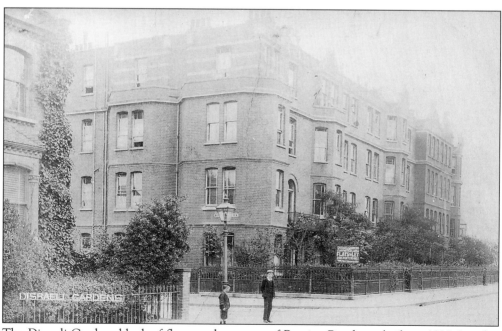

The Disraeli Gardens block of flats on the corner of Bective Road was built in 1897-8 and is seen here c1906. A local authority initiative was to put the road names on the street gas lamps. The notice on the corner lamp announces that Bective Road has been reached.

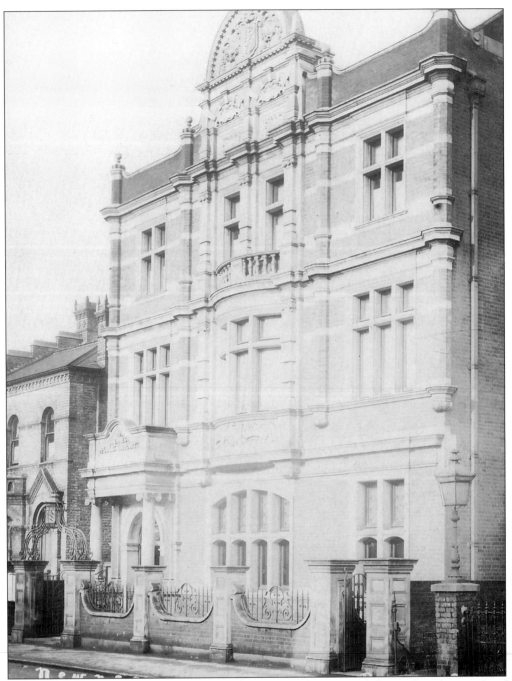

Putney Library, Disraeli Road, c1906. The library was paid for and donated to the people of Putney by George Newnes when he lived at Wildcroft on Putney Heath. Designed by Mr F.J. Smith, the building cost £16,000 to erect in 1898 and was opened by Lord Russel of Kilowen on 6 March 1899. The widespan wooden-beamed roof of the reading room is a notable feature, as is the bust of the benefactor in the entrance hall. From 1986 to 1995 it housed the Wandsworth Museum, in the front half of the building, before this transferred in 1996 to the old Court House in Garratt Lane.

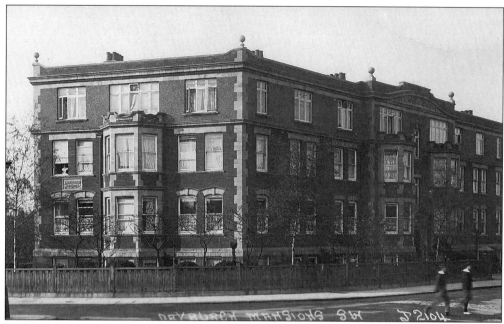

Dryburgh Mansions c1912. This block of flats on the corner of Erpingham Road and Egliston Road has recently undergone a stone cleaning and refurbishment programme and now looks much as it would have when built in 1902.

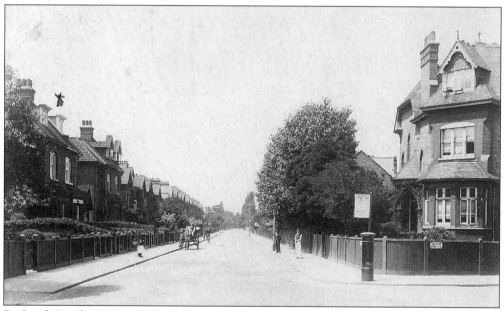

Dryburgh Road c1905. Development quickly followed approval of the road name in 1884, the majority of properties dating from before 1900. The planning application for the house on the corner of Egliston Road, 2a Dryburgh Road, for example (above and opposite), was submitted in 1886. In 1910 it was the home of Rowland Arthur Kirby MB, BA Camb, MRCS, LRCP, physician and surgeon. Adapted into four flats after the Second World War, it has now reverted to a single household and the adjoining tennis courts are now part of the garden. The wooden fence has been replaced with a brick wall in recent years.

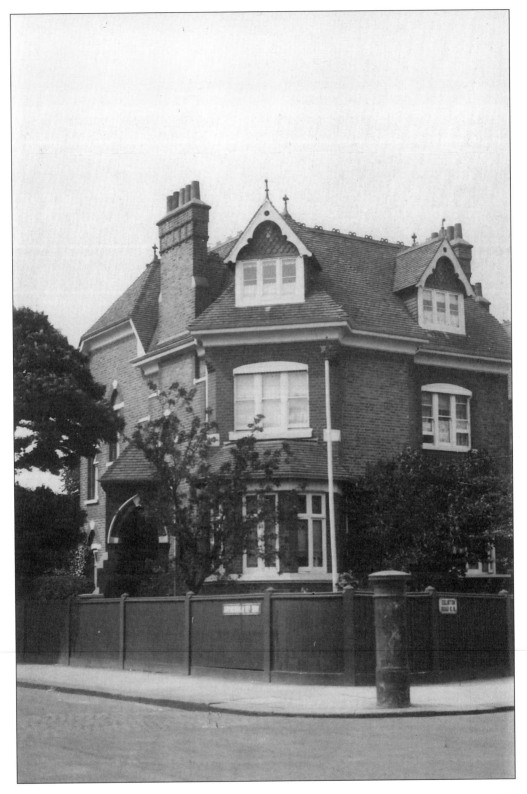

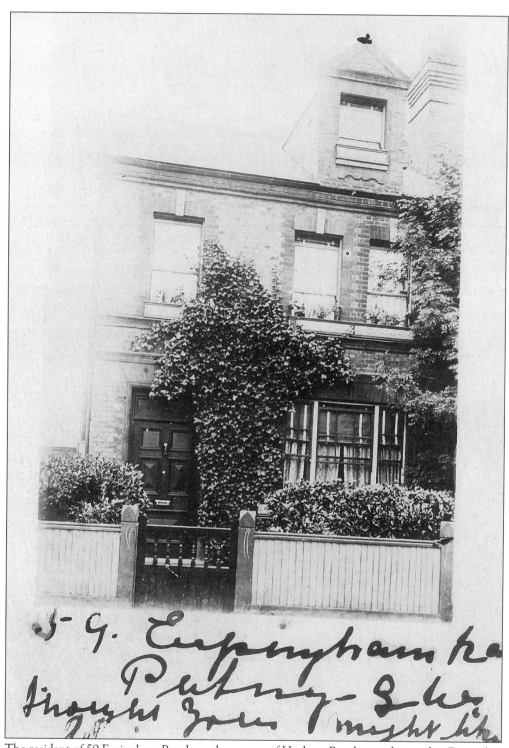

The resident of 59 Erpingham Road, on the corner of Hotham Road, sent this card in December 1907 with the sole message, 'I thought you might like this.' The road name was approved in 1877 but building operations did not commence until 1884 and continued into 1903.

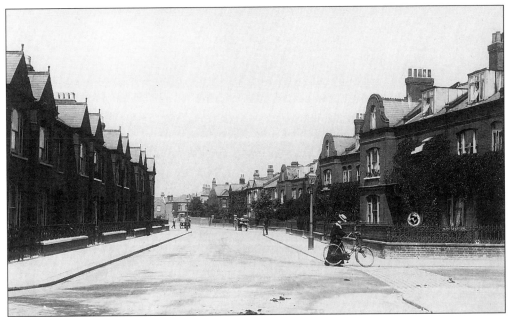

Felsham Road c1905. The eastern end of the road was called Gardener's Lane and had been built on in the seventeenth and eighteenth centuries. The western half was built on from 1877 and the name change occured in 1907. The woman and child are standing in front of number 169 Felsham Road, from where, in December 1909, they moved to nearby 9 Roskell Road.

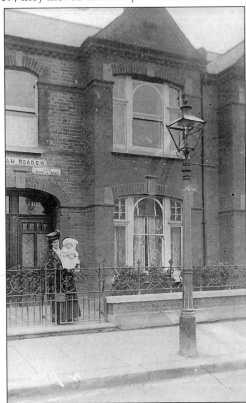

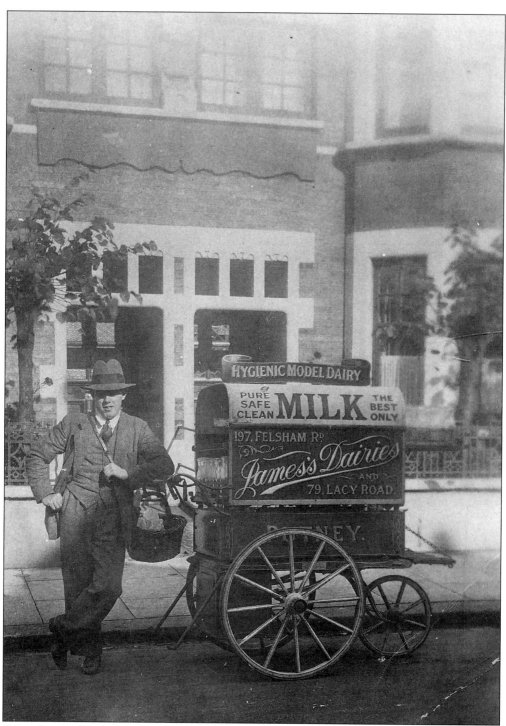

A hand-pushed dairy cart (c1925) from James's Dairies, who had premises at 197 Felsham Road and also at 79 Lacy Road. Dairy products had to be delivered several times a day before ownership of refrigerators became commonplace in the 1950s. Larger households, such as those on Putney Hill, might have had three deliveries a day.

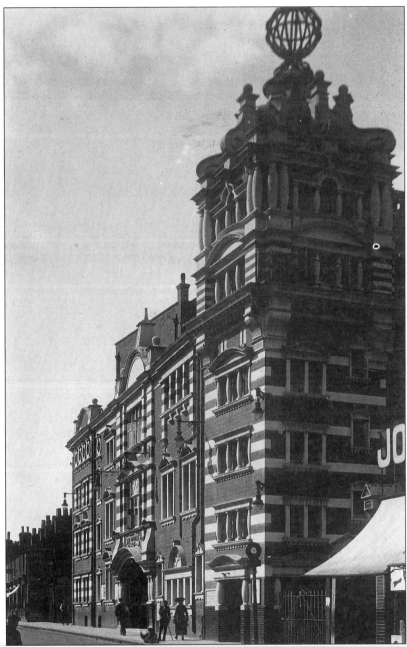

The Putney Hippodrome theatre, Felsham Road, c1912. The foundation stone was laid on 31 March 1906 by Henry Dixon Kimber, eldest son of Sir Henry Kimber, first MP for the Borough of Wandsworth. Built as a 2,000 seat music hall, films had been screened during the First World War and the building was converted for cinema programmes in 1924. For those wondering what the interior decoration was like, the theatre's last 'performance' was in 1972 as the setting for a Vincent Price horror film entitled *Theatre of Blood*. Various murders in the film take place within and around the theatre, which was eventually seen 'in flames'. The flames were not for real, but the theatre and the adjoining brewery bottling plant (another 'star' in the film) were soon demolished.

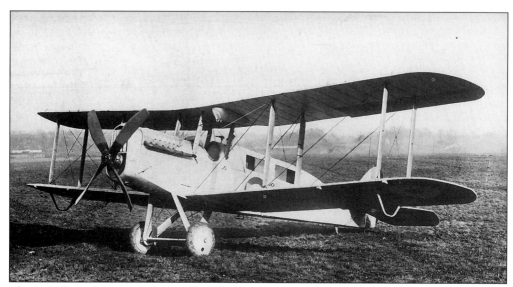

The Palladium Autocar Co. moved to Felsham Road in 1914 as manufacturers of small private cars, although the major production was of commercial vehicles, lorries and buses, the lorries being used by some of the early petrol companies. During the First World War the firm's products were diverted to military uses. In 1918 they were awarded a contract to construct 100 de Havilland DH4 biplanes. Unable to see service in the war, several were converted for passenger use by the installation of a cabin and two extra seats. They were painted white overall, as seen above, and used by No. 2 Communication Squadron 86 Wing RAF, conveying cabinet ministers between London and Paris during the armistice negotiations.

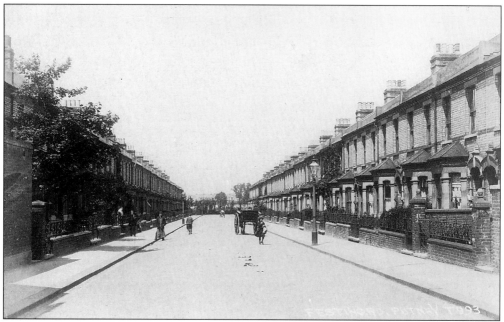

Festing Road c1906. The developers in this road took their time putting up the houses, starting in 1887 with six properties on the east side and then building on alternate sides until 1894, with a few more each year up to 1902, when the last, No. 71, was applied for.

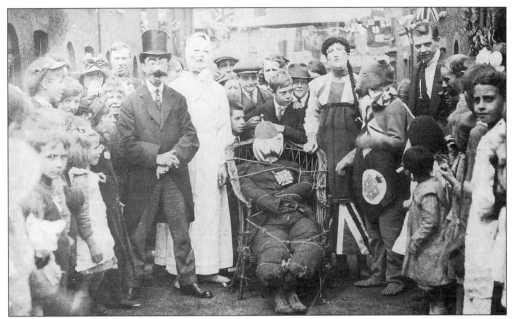

The residents of Gay Street dress up and enjoy themselves on Saturday 19 July 1919, the officially sanctioned day for peace celebrations. Tied in the chair is an effigy of the German Kaiser, no doubt later to be placed on the bonfire. In the background can be seen the shops in River Street, demolished with Gay Street in the 1960s and covered over by the Platt housing estate off Felsham Road. The remainder of River Street is now called Waterman Street.

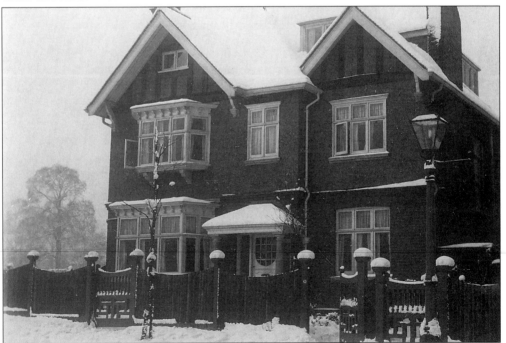

Wynnstay, 8 Genoa Avenue, covered in snow in about 1908. Beyond the house is Chartfield Avenue, with much of the land yet to be built on. Wynnstay looks quite similar today, except for the addition of a small timber and brick garage to the left, built in 1922.

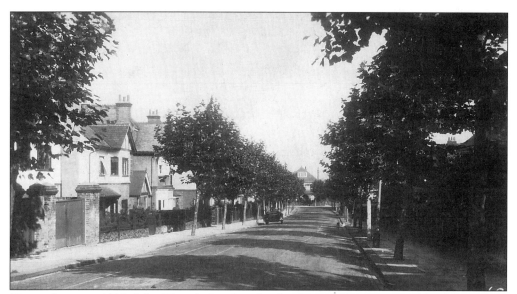

Genoa Avenue c1930. John Temple Leader, the developer of large tracts of land in Putney, lived the last years of his life in Florence, purchasing the castle of Vincigliata and restoring it. Several roads in Putney no doubt reflect his life in Italy: Ravenna Road and Genoa Road and possibly Castello Avenue, each built in the years 1905-06.

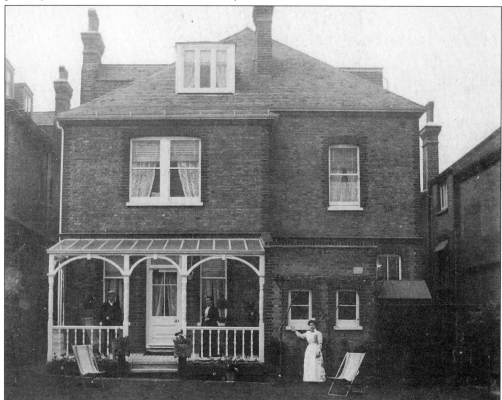

Beresford, 13 Genoa Avenue, c1908, home to Mr Harry Osborn, with deckchairs placed on the lawn and what looks like a nurse in attendance.

Gwendolen Avenue c1906. Although the major portion of the avenue was laid out by 1887 as part of the Putney Hill Park estate, a full road surface was not laid for some years, and by 1894 only two properties had appeared. The names of those houses depicted here were Banavie at No. 17 and Normandale at No. 15.

Hotham Road, at the corner of Charlwood Road, in 1906, with a postman going about his rounds. This row of houses, named Hotham Villas and dating from the mid-nineteenth century, were demolished for the erection of Hotham Road School.

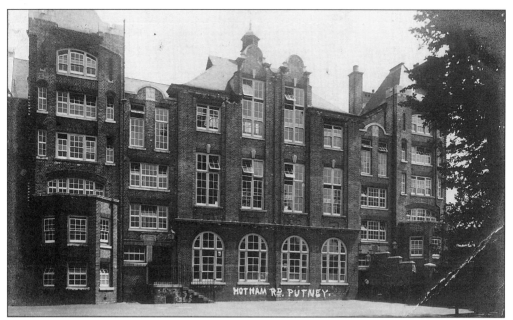

Hotham Road School. The London County Council built the school in 1908-9 and it was opened on Friday 22 November 1909. Behind the school is St Mary's Hall, whose foundation stone was laid by Samuel Samuel MP on 9 October 1913. This large hall, built with the gift of a private donation and used for wedding receptions and dances, is now empty and awaiting conversion into housing accommodation.

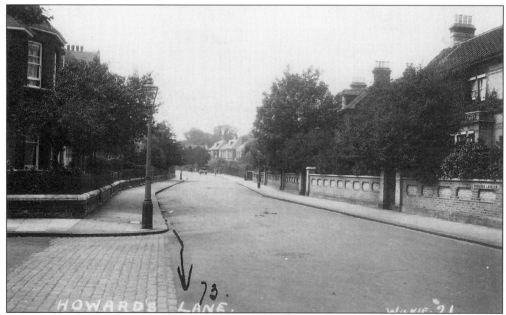

Howard's Lane c1930, a very old track between the fields. In a map dated 1787 it is called Warple Way, and it probably dates from the early medieval period. It led from Putney parish church to Roehampton. The main traffic before development commenced in 1894 would have been agricultural in nature or that generated by the few early 1850s properties in Coalecroft Road.

Larpent Avenue c1930. The Larpent family lived in Putney Park House in the 1820s and 1830s, and in 1825 George Larpent owned a large property to the south of Fairfax House in the High Street. Building development took place from 1903 to 1906, a little later in this road than others in Putney. The author and his family lived in a halfway house, temporary accommodation provided by the local authorities, at No. 33 for six months in 1949-50 before moving into a prefab in Atney Road.

Lytton Grove c1906. To the right is Holmbush Road. Although permission to develop Lytton Grove was given in 1866, only six houses had been erected by 1894 and the road from Putney Hill stopped at a dead end at what was once called the Putney Gutter. This was a stream running off Wimbledon Common and down towards the area of Deodar Road and Wandsworth Park. This ditch formed the parish boundary between Putney and Wandsworth and is the reason for the dip in Lytton Grove. The road was later extended toward West Hill.

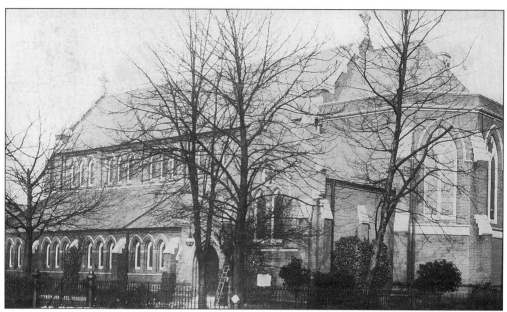

St Stephen's church, Manfred Road, 1906. The church originated as an iron church, opened on 2 December 1877. The foundation stone for the enlarged church was laid in 1881 and consecrated by the Bishop of Rochester on 1 November 1882. This building was found to be too large for the congregation and demolished in 1979. A new smaller church was dedicated by Mervyn Lord Bishop of Southwark on 23 July 1980, and excess land developed with flats called St Stephen's Gardens. A signed portrait of Queen Elizabeth the Queen Mother was presented by her to the church as it was dedicated in her eightieth year.

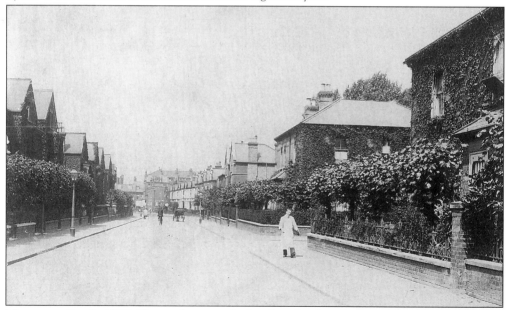

Montserrat Road c1906. The road is named after the island in the Leeward group in the West Indies. The house on the corner of Atney Road, on the right, survived into the 1960s when it was demolished and replaced by a small block of flats. The other houses here have survived rather well without too much alteration.

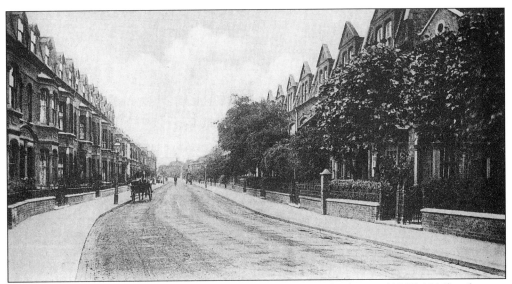

Norroy Road c1906. The road name derives from George Cockayne (1825-1911), who was Norroy King of Arms from 1882 to 1894. He lived in Ashbourne House, demolished in 1887 for development of this road in the same year.

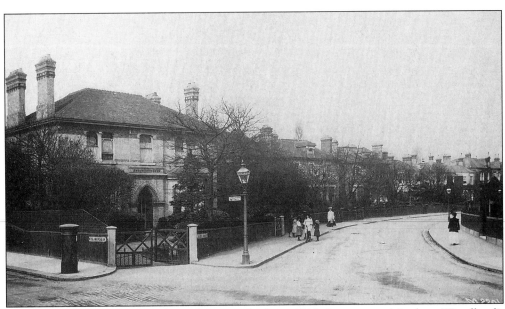

Oakhill Road c1906. When the railway was built in 1845-6, access to Matthew Woodland's farm, on either side of the railway cutting, was provided courtesy of the LSWR by a small bridge, now called Woodland's Way, to the left in this scene.

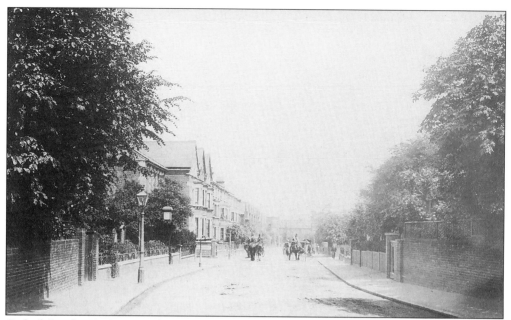

Oxford Road c1906. Formerly called Starlings Lane, the present name, which honours the Varsity boat race, was given when development started in the 1880s. On the left was the Congregational Institute and schoolroom, taken over by the boy scout movement and in use by them as the headquarters for the 1st East Putney scout troop, which is seen below on 9 March 1911 at camp preparing their food.

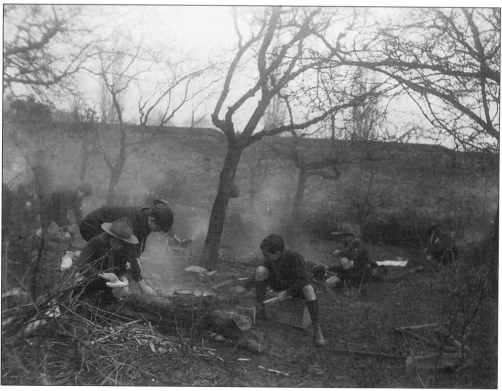

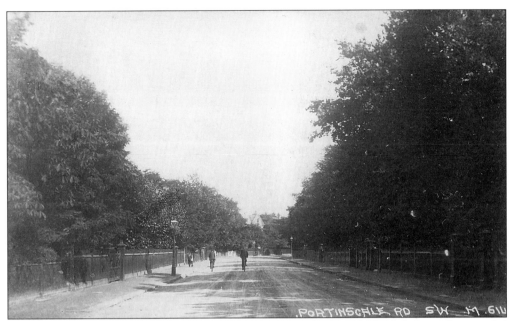

Portinscale Road, between Keswick Road and West Hill, in 1906 has the air of a wooded avenue, but behind the trees were seventeen large houses, erected by 1894. Clement Attlee's family lived at No. 18 until the early 1920s. He was Prime Minister from 1945 to 1951. The northern side has been demolished and council flats built at the western end, and extensions to Mayfield School at the eastern end have swallowed up more land. Even the south side has succumbed to modern flats and only the one 1880s property survives, on the corner of West Hill. Both Keswick and Portinscale are Lake District names.

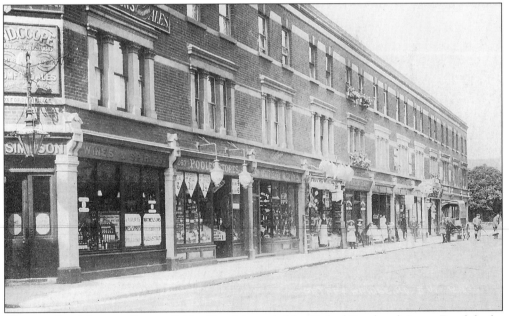

This parade of shops in Putney Bridge Road, bounded by Oxford Road and Atney Road, had a variety of outlets in 1906. On the left was Simpson's wines and spirits store, John Poole's groceries, Carter and Co., wallpaper merchants, and A. Taylor, oilman.

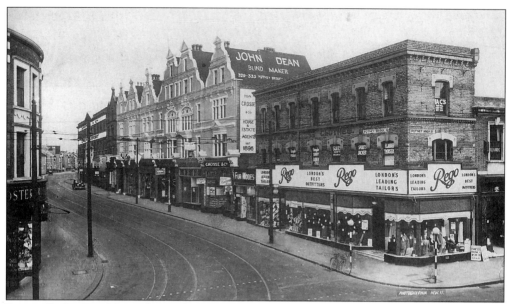

Putney Bridge Road from the High Street c1930. At the far end of the block, on the corner of Burstock Road, stood the indoor swimming pool and Turkish baths built in 1886. The baths closed in 1913 and were used as offices and classrooms by Battersea Technical College until they were demolished in 1985. The replacement block of offices is occupied by VSO (Voluntary Service Overseas). J. Dean and Co. had their works and showrooms in this parade. Above Rego's tailors in the late 1930s was the Black and White milk bar and dance hall which suffered a direct hit on 7 November 1943, 81 being killed and a further 210 injured in what was the worst incident in wartime Wandsworth.

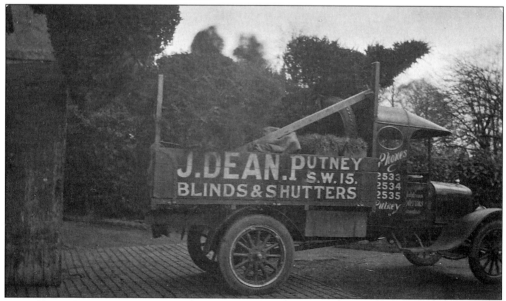

A small metal plate, often observed from the top of a bus, can be seen on many shop blinds and states, 'Deans Blinds-maker Putney'. These were manufactured by J. Dean and Co. at their Russel Yard premises in Putney and this small drop-sided lorry would deliver their shutters, shop blinds, flags and tents during the period after the First World War.

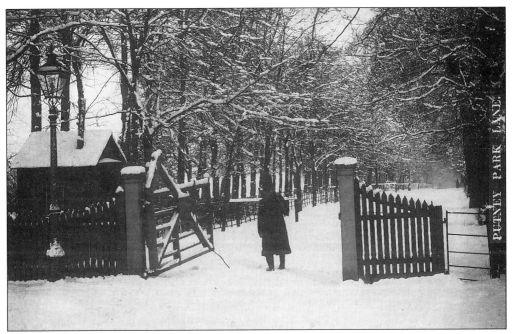

Putney Park Lane after a recent fall of snow c1908. The park was established in the thirteenth century as a deer park to supply the manor house at Mortlake with venison. James I used the park as his hunting ground but it was sold in 1626 and turned over to agricultural use in 1636. The land was split up and used for villa estates in the eighteenth century.

St Margaret's church, Putney Park Lane, c1930. This church was built about 1859 as a private chapel and after various uses was given to the Church of England in 1912, not becoming a separate parish until 1923.

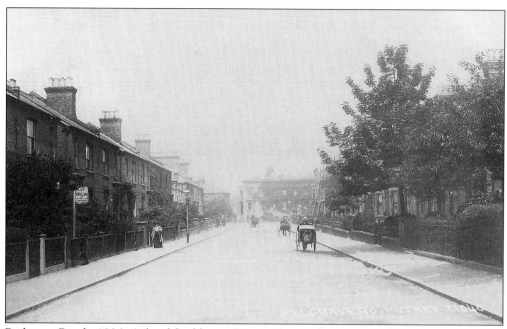

Redgrave Road c1906. A local builder in Putney during the 1870s and 1880s was Mr F.W. Pearce, who was born at Redgrave in Suffolk.

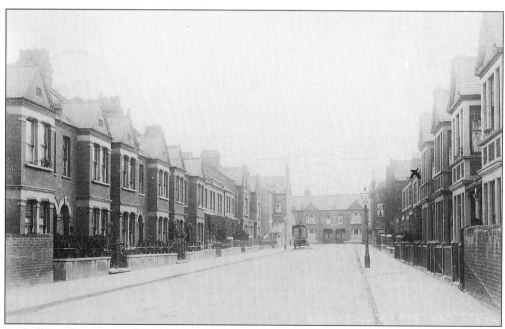

Roskell Road c1906. Bricks and mortar came to this road with a flourish in 1887 with a proposal to erect eleven houses, and then development slowed down, separate developers erecting small blocks of four to five houses every two years up to 1896.

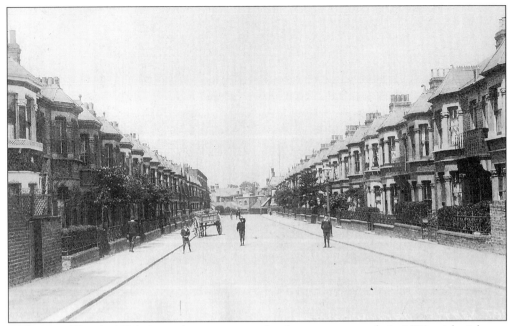

Rotherwood Road c1906. An ambitious start to development was made in 1892, with eighteen houses erected on the east and sixteen on the west side. After the initial rush six more properties were planned for 1894, another four in 1896 and the last six in 1897.

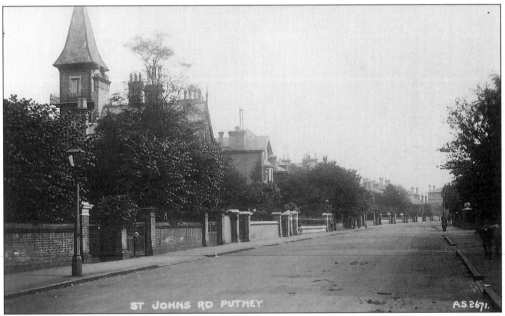

St John's Avenue c1912. The road name was approved in 1867 as St John's Road and followed the building of St John's church. A few properties were built near the church in the 1860s but by the 1890s the majority of the houses had been built on the east side of Putney Hill, the western part retaining its nurseries. All these large houses on the eastern arm have been demolished, with the exception of the house on the left with the corner tower.

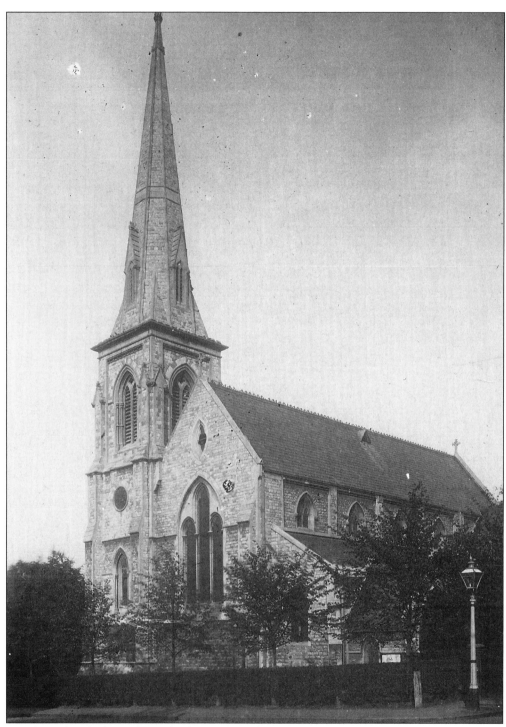

St John's church (c1912) was built to relieve pressure on St Mary's and was consecrated in 1859. It was mainly paid for by the local developer and landowner John Temple Leader. Enlarged in 1888, the church was declared redundant in 1977 and has since been used by the Polish Roman Catholic community.

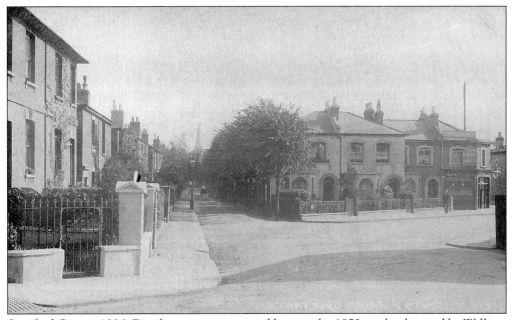

Stratford Grove c1906. Development commenced here in the 1850s on land owned by William Stratford. To the right is Cardinal Place, which leads into Quill Lane, part of the medieval route to Roehampton from St Mary's.

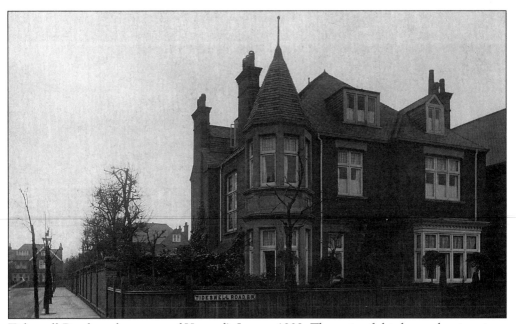

Tideswell Road, at the corner of Howard's Lane, c1908. The twin of this house, but in mirror image, stands at the upper end of the road where it meets with Hazlewell Road.

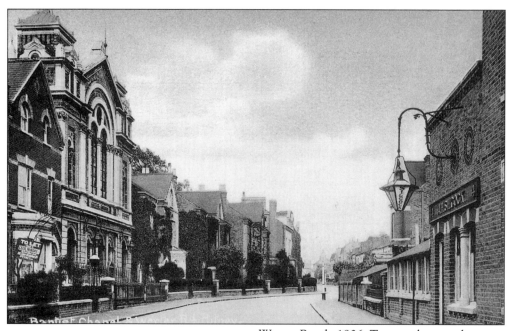

Werter Road c1906. To complement the naming of Oxford Road after the Varsity boat race this thoroughfare was to be called Cambridge Road but the Metropolitan Board of Works, predecessor of the LCC, wanted to remove too many similar names from each quarter of London and Battersea kept its Cambridge Road. Putney gained Werter Road in 1875. The Baptist church, on the left, was built in 1884, the memorial stone being laid by W.F.A. Archibald Esq. on 8 May 1884.

Taylor's Villas, previously Taylor's Buildings, just off Lacy Road and approximately thirty yards west of the Jolly Gardener's public house, ran in a southerly direction towards Quill Lane. When demolished in the 1950s, shortly after this photograph was taken, an outer layer of plaster fell from the arch above the doorway in the photograph, and on the arch in black paint on whitewash in Gothic script were the words 'Trafalgar Cottage 1812'.

Eight
Roehampton

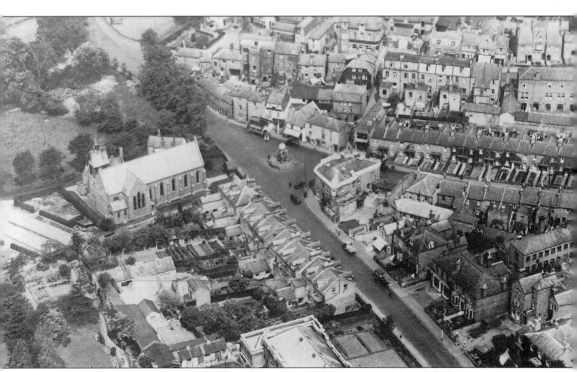

Roehampton from the air c1925. Medfield Street is at middle right and the High Street is at the top. The Earl Spencer public house is at the centre and St Joseph's Catholic church is to the left.

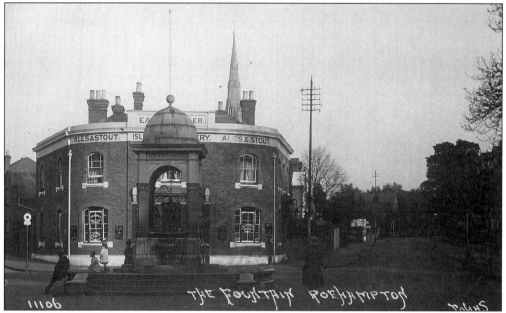

The fountain at the bottom of Medfield Street (c1912) was erected in 1882 by the widow of Stephen Lyne Stephens MP, who lived at Grove House, now part of the Froebel institute. It was built of granite, with a central bronze statue of some small boys with a fish, by the French sculptor Henride Cusson.

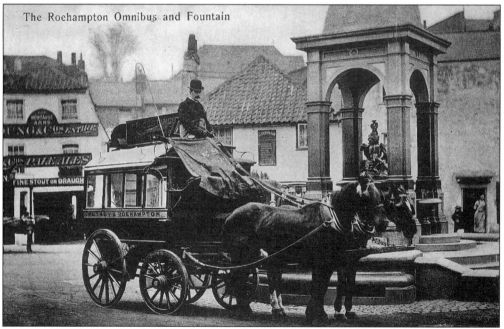

The Putney horse-drawn bus from Roehampton c1905. Painted black, the bus gained the nickname of 'Black Maria'. In the background is the Montague Arms public house, which is named after George Montague, Duke of Manchester (1737-1788), who had stayed in Roehampton for a time.

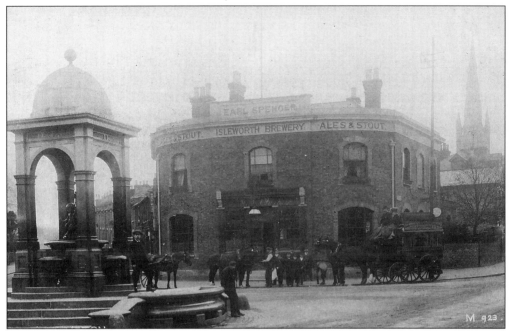

The Earl Spencer public house in 1906, with the Putney bus waiting for departure, the two horse troughs at the fountain providing the refuelling stop. The pub is named after the Lord of the Manor of Wimbledon which included Putney and Roehampton. The Duchess of Marlborough purchased the manor and title in the eighteenth century and bequeathed it to her grandson, John Spencer of Althorp, Northamptonshire.

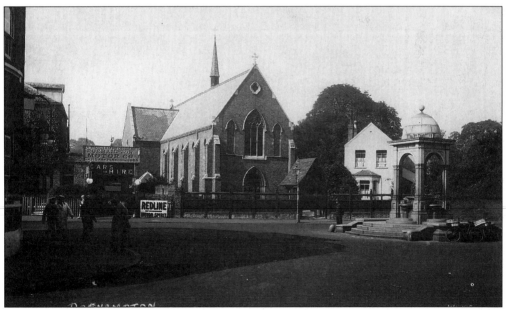

St Joseph's Roman Catholic church c1930. The church was consecrated in 1881. The oak lych gate was moved to the north of the church after Roehampton Lane was widened in 1963.

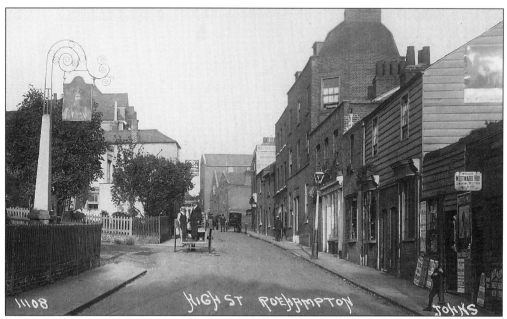

Roehampton High Street c1912. A dairy cart makes its way up the hill past eighteenth-century houses and shops. Patching newsagents on the right produced and sold an interesting series of local postcard views before the First World War.

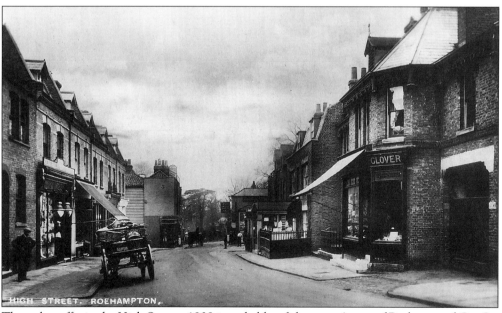

The only traffic in the High Street c1908 is probably a fishmonger's cart of Rudman and Co. On the right is the confectioners shop of Glover and Son.

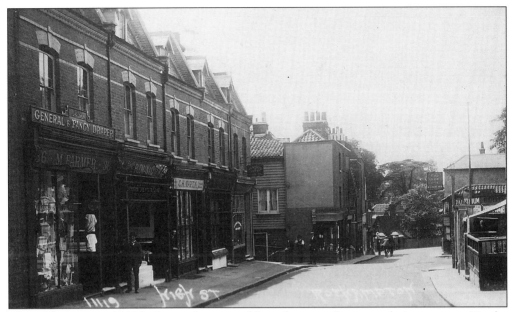

The High Street in 1912 had a good variety of shops but not a large population to serve. On the left is M. Farmer's general and fancy drapers. The fishmongers, Rudman and Co., were licensed dealers in game. At the far end of the parade is Edward James' dairy.

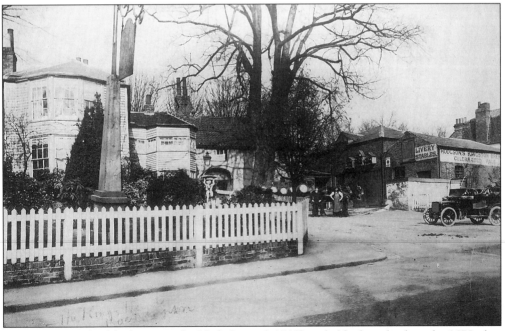

The King's Head public house in the High Street (c1910) probably dates back to the 1670s, but as a pub only to the 1720s, when it was called the Bull. A brewery dray is delivering a fresh supply for the pumps and an early motor car is parked near the livery stables.

Treville Street c1908. The house on the right was used as the Roehampton Working Men's Club at the turn of the century and later as the Roehampton Conservative Club premises. To the left is Spencer Cottage.

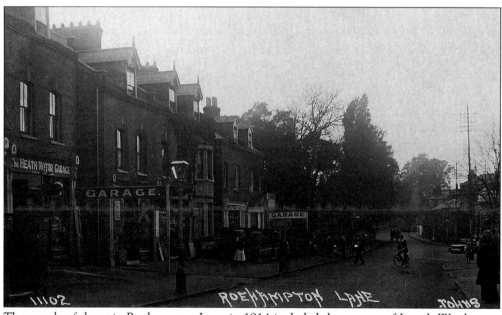

The parade of shops in Roehampton Lane in 1914 included the grocers of Joseph Woolmer, a cycle shop and two motor repair and spares shops. This row of shops was demolished for widening of the lane in 1963.

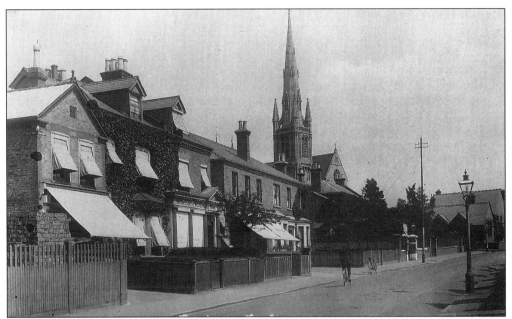

This small group of shops survived the 1963 lane widening, but back in 1910 had included a branch of the London and South Western Bank and Windsor and Sons furnishing shop. The small building on the left was the premises of John Harvey and Sons, builders, ironmongers and farriers. Holy Trinity church was built in 1896-7 to the designs of G.H. Fellows Prynne and opened for services in 1898. The spire is 200 ft high.

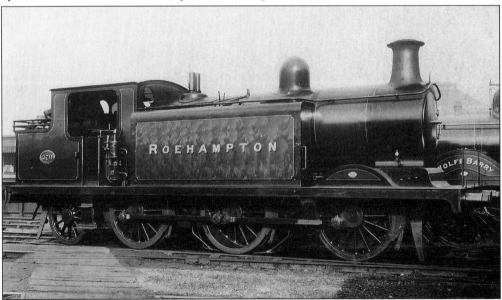

The London Brighton & South Coast Railway Co. named virtually all of their engines and here we have locomotive No. 579 *Roehampton*. This 0-6-2 'E4' class engine was built at Brighton in June 1903, a probable date for the photograph. The highly polished finish was achieved by rubbing the paintwork with tallow. Seventy-five of these engines were built to the designs of the chief mechanical engineer Robert J. Billington, some surviving beyond nationalization into the 1950s.

Manresa House c1908. Built about 1760 for William, 2nd Earl of Bessborough and originally named Parkstead, the house was bought by the Jesuits in 1861 as a Catholic teaching college and renamed Manresa after a town in Spain associated with St Francis Xavier. They remained until 1962 when the building was taken over by Battersea Training College of Domestic Science, and it is now part of the Polytechnic of the South Bank. Part of the Alton housing estate, built 1954-9, occupies some of the former grounds, as do the taller blocks on the estate erected in 1967-9. In front of the house can be seen a sunken wall or 'HaHa' built to stop animals from entering the house grounds without spoiling the view, which a conventional wall would have done. The name supposedly derives from the surprise a pedestrian might get upon encountering this unexpected obstruction.

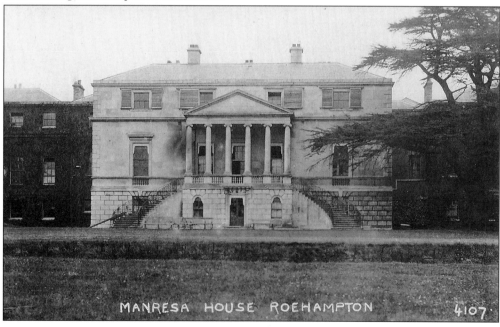

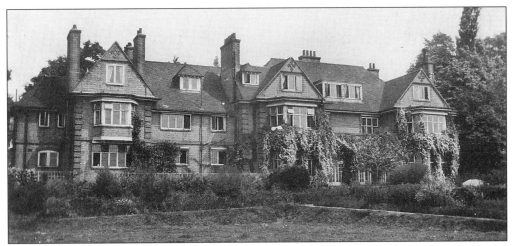

Primrose House, Clarence Lane c1915. During the First World War the Royal Naval Air Service used the grounds of the nearby Roehampton Club for their No. 1 Balloon Training Wing, which had its headquarters at nearby 331 Upper Richmond Road. Free and tethered balloons were a common site above Priory Lane, as were the RNAS airships *Delta* and *Eta*. With flying taking place on Wimbledon Common and Richmond Park, the RNAS used Primrose House as a hospital. The house was built in 1906 for Hugh Colin Smith of Mount Clare, who died in 1910 without taking up occupation. The first resident was Gen. Charles John Cecil Grant (1877-1950). He married Lady Sybil Primrose, daughter of Lord Rosebery. Sir George Tilley took up residence about 1932 and died there in 1948. The GLC had planned to use it as school for the mentally handicapped but it was demolished in about 1965 and flats built on the site.

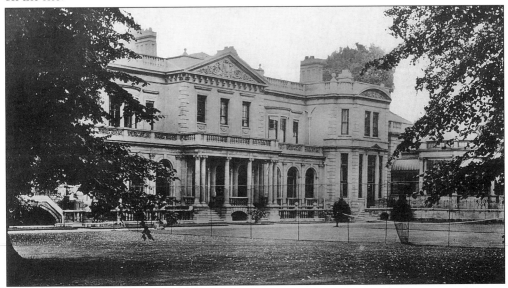

Gifford House c1913. This large house was situated on the south east of Putney Park Lane, facing Putney Heath. It was built in the 1750s and an early resident was the Attorney General, Lord Robert Gifford, chief prosecuter in the trial of Queen Caroline and also of the Cato Street conspirators. It was rebuilt around 1890. Used as a hospital during the First World War, the house was demolished about 1950 and the site is now covered by the western end of the LCC Ashburton housing estate.

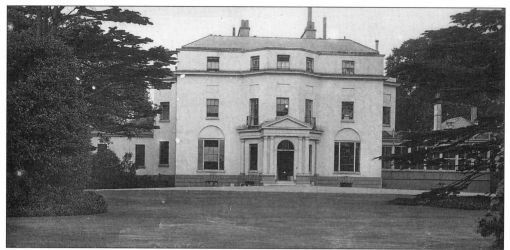

Dover House (c1913) was built in 1764. Lord Hawkesbury, later the Earl of Liverpool, Prime Minister 1812-27, was a resident here at the beginning of the nineteenth century. A later resident was Earl Clifden, who was also Lord Dover. The last single resident was the American millionaire, John Pierpoint Morgan, who died in 1913. The house, like so many others in Roehampton, was used as a hospital during the First World War but was demolished in 1919-20 by the LCC, which developed the northern part of the grounds as the Dover House housing estate; the southern part was privately developed as Westmead, Highdown and Parkmead Roads.

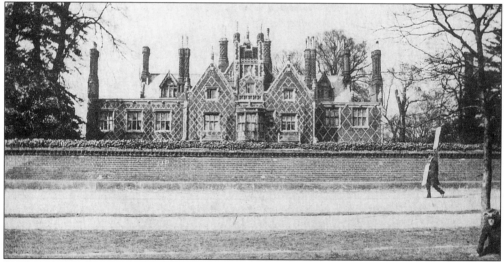

Ashburton House c1906. The original house was built about 1750. John Dunning, 1st Baron Ashburton, a successful lawyer who rose to become Solicitor-General, lived here from 1772 to 1783. A later resident, and of Ashburton lineage, was Alexander Baring, a statesman. He concluded a boundary dispute between the USA and Canada with the Ashburton Treaty of 1842. Francis Baring occupied the house from 1784 to 1789, although the Baring family owned the property until 1806. Thr house burnt down in October 1835 and during demolition a Mr Williams, proprietor of the Rose and Crown public house next to St Mary's church in Putney High Street, was killed by the collapse of a wall. The house, rebuilt of brick in the Tudor style, was bought by the LCC in 1948 and demolished in about 1950. The Ashburton housing estate was soon erected in the grounds.

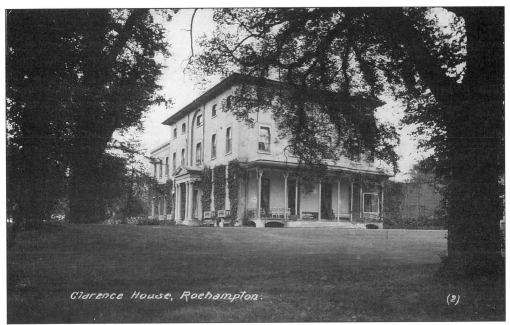

Clarence House c1912. The house, built about 1780, stood about halfway along Priory Lane, on the west side. Resident in 1787 was Stamp Brooksbank, and in 1790-1 the Duke of Clarence, later William IV. The house was occupied from 1841 to 1856 by Richard Henry Beaumont. From 1867 to 1919 it was in use as the Royal School for daughters of military officers. The 1881 census lists the headmistress, Miss Caroline Lane, and five other teachers plus fourteen servants attending to fifty-two girls aged 11 to 14. In 1919 it was bought by the Bank of England and demolished in 1934 to be replaced by the bank's record office; the grounds are now a sports ground and playing fields to the south of Bank Lane.

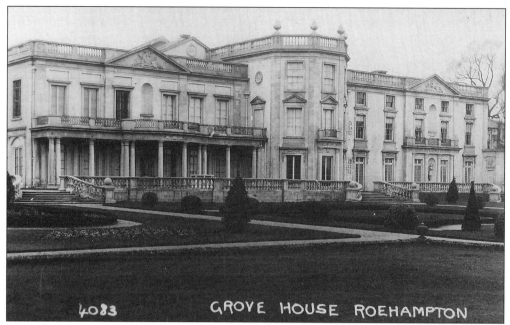

GROVE HOUSE ROEHAMPTON

Grove House c1912. The house, designed by James Wyatt and John Adam, was built around 1790 for Joshua Vanneck, Baron Huntingfield. The politician Stephen Lyne Stephens lived here during the mid-nineteenth century and the War Office was in control from 1914 to 1921 when it was acquired by the Froebel Institute.

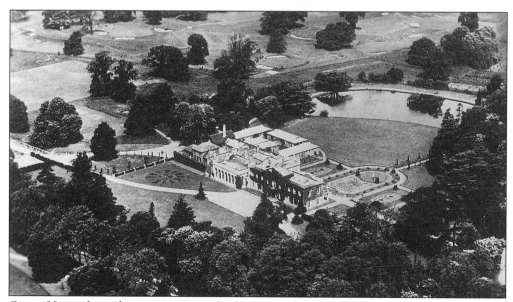

Grove House from the air c1925. In the background is the golf course and grounds of the Roehampton club, whose main entrance is off the northern part of Roehampton Lane.

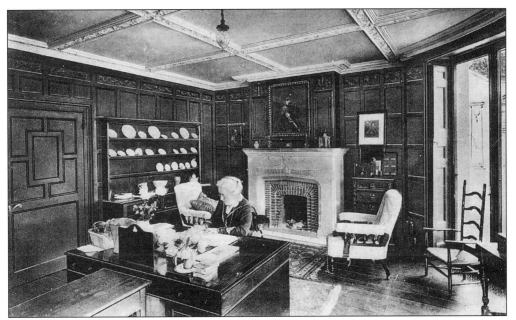

Grove House c1922. The upper view is of the principal's room shortly after the Froebel Institute bought the house. The view below is of the the new intake of students studying in the library. In 1975 the Institute joined with the neighbouring Digby Stuart College, together with Southlands College and Whitelands College, to form the Roehampton Institute of Higher Education, perhaps the first step to becoming a university and a student gaining a BA (Roehampton) at some time in the future.

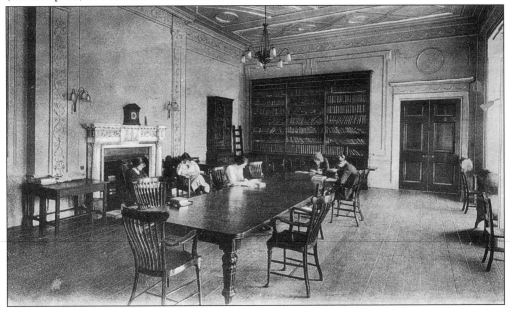

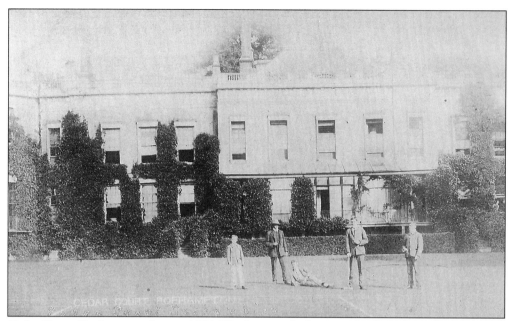

Cedar Court, Roehampton Lane, c1906. The house, which appears to have been demolished in about 1910, was occupied in 1787 by Andrew Tompson, whose daughter Maria married Joshua Vanneck (see p. 110) in 1777. The house was in use as part of the military college attached to the Downshire estate, and the Cedars Cottages, still standing on the corner of Clarence Lane, were outbuildings of Cedar Court.

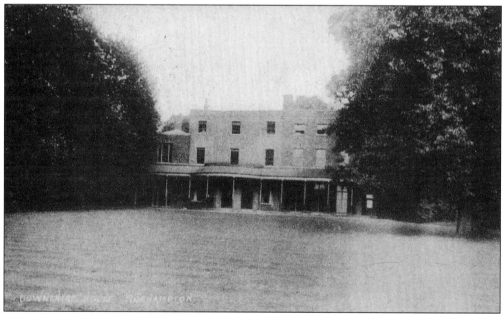

Downshire House, Roehampton Lane, c1903. Erected about 1770 for General James Cholmondeley, the house was the residence of the Marchioness of Downshire at the turn of the eighteenth century. An academy for Army and Naval students from 1900 to 1910, it was bought in 1963 by Garnet College for technical teachers as part of Greenwich University. Part of the Alton West housing estate was built in the grounds.

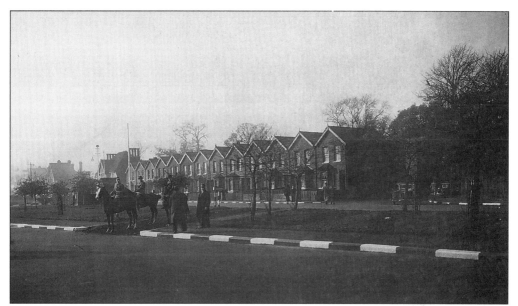

Horses and riders crossing the A3 Kingston Road from the Robin Hood gate of Richmond Park, heading towards Wimbledon Common, c1935. The Kingston bypass, off to the left, opened in 1927 to alleviate traffic pressure on Kingston town, was Britain's first bypass.

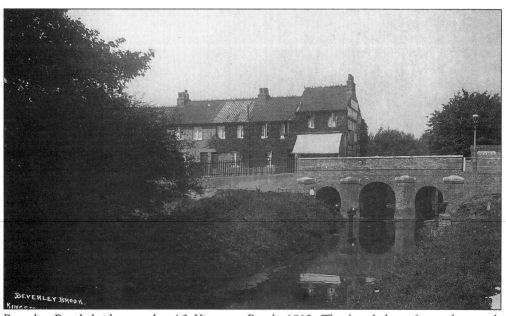

Beverley Brook bridge on the A3 Kingston Road c1912. The brook here forms the parish boundary between Putney and Kingston and is probably named after beavers that either once lived along the river banks or were bred for their fur during the medieval period.

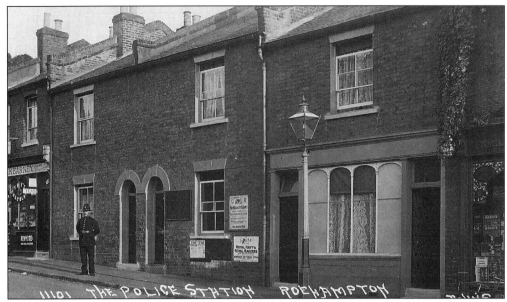

Roehampton police station, Medfield Street, c1912. There are two £50 reward notices on display together with recruiting posters for the Army, Navy and Marines. A close inspection of the building today will reveal where these notice boards were attached to the wall. The confectioners on the left was owned by J. Kearney.

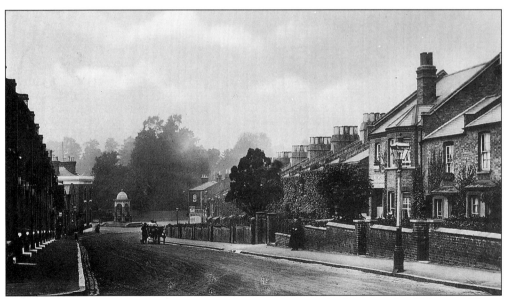

Medfield Street c1907. In the distance can be seen the trees in the grounds of Manresa House and Downshire Lodge. Danebury Avenue and the Alton West housing estate now occupy the area. In the first half of the twentieth century No. 87 Medfield Street was the Hambro Home for Girls, maintained by the Church of England Waifs and Strays Society. The orphanage was managed by Miss Lamble, Lady Superintendent, in 1910 and a Miss Freeling, Matron, in 1934.

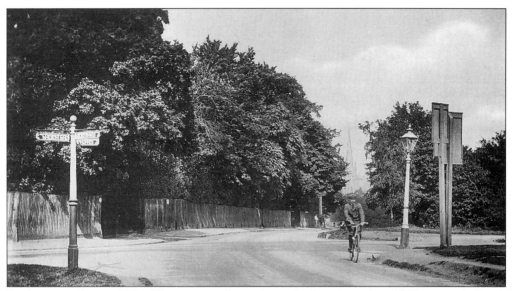

Roehampton Lane c1907. This crossroads is where the lane met the old Portsmouth Road, another of the smaller roads that was grassed over as compensation when the Tibbet's underpass was opened in 1970. Scio House stood approximately 200 yards to the north-east, i.e. to the right of the cyclist.

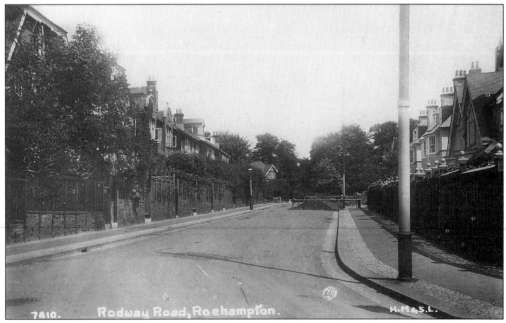

Rodway Road c1910. Beside the few shops in the High Street and Roehampton Lane, late Victorian development in the area was sparse but it did include the few roads around Nepean Street, Umbria Street, Akehurst Road and Rodway Road.

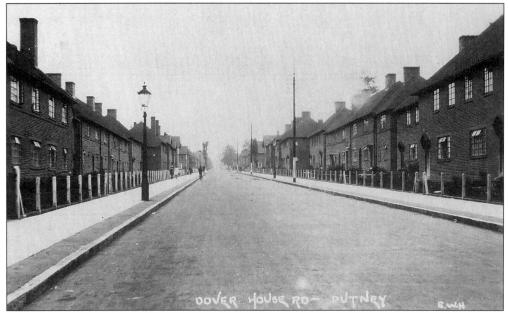

Dover House Road c1930. The housing estate, comprising 1,212 houses, was built by the LCC from 1923 onwards on the old Dover House estate. The southern part of the grounds were left to private developers and included Nos 283 and 285 (Landithy) Dover House Road, built between 1925 and 1928, on the right.

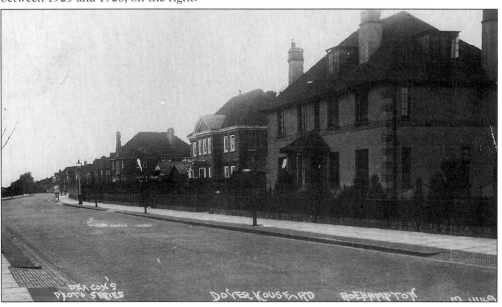

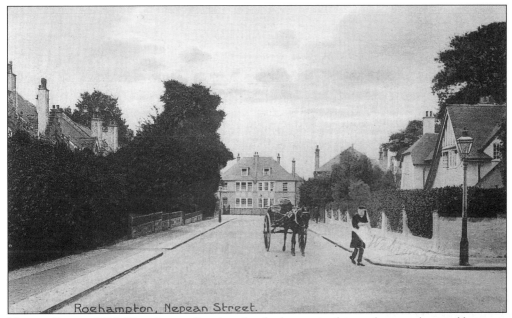

Nepean Street c1906. Planning applications for the houses in this road were submitted between 1899 and 1901 at the rate of only a few each year. Deliveries by horse and cart would have been common well into the 1930s, the occasional horse-drawn delivery of bread and milk still occurring into the 1950s.

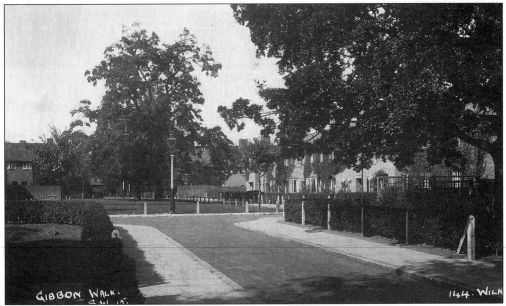

Gibbon Walk c1930. The LCC had local literary personalities in mind when it was considering the names of roads on the Dover House estate. Among the names are Lysons Walk (after Daniel Lysons, deputy curate at St Mary's, Putney, 1792-1799, who wrote *The Environs of London* between 1792-6), Swinburne Road (after Charles Swinburne, see p. 56) and Gibbon Walk after Edward Gibbon (see p. 55).

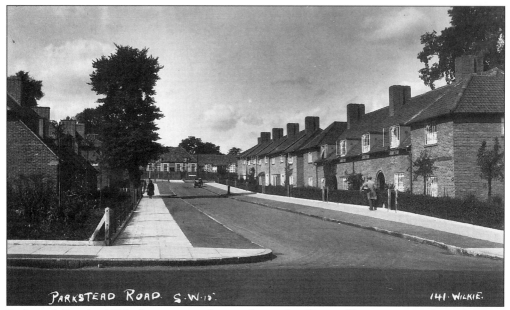

Parkstead Road c1930. In naming this road on the Dover House estate, the LCC was attempting to recall the thirteenth-century deer park and also Putney Park House nearby.

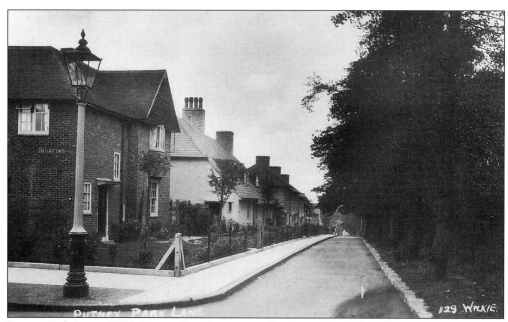

Putney Park Lane c1930. To confuse the unwary there are two roads called Putney Park Lane. On the right, beyond the trees, is the original lane, which still retains a gravel surface. The LCC, which had control over the naming of roads within London, inexplicably used the name again when building the Dover House estate in 1923, and both are parallel to each other for approximately 100 yards.

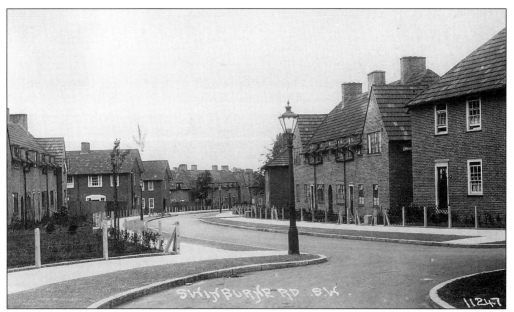

Swinburne Road, Dover House estate, c1935. As with Gibbon Walk and Lysons Walk, Swinburne Road was named in honour of one of Putney's literary names.

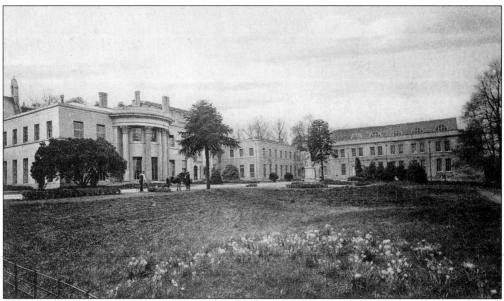

Convent of the Sacred Heart, Roehampton Lane, c1908. The first house here, Elm Grove, was built shortly before 1622 by David Papillon, a French Huguenot. William Harvey (1578-1657), physician to James I who immortalized his name by discovering the principles of the circulation of blood, spent his last years here. The house burnt down in 1795 and was replaced in 1797 with a new Elm Grove for Benjamin Goldsmid. Admiral Horatio Nelson spent his last full night in England here in 1805.

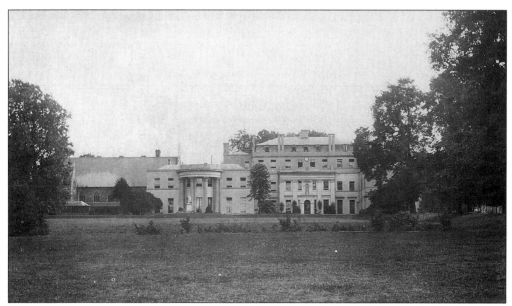

In about 1848 the Society of the Sacred heart bought the house and grounds. The house, seen here c1908 slightly left of centre with the portico, was badly damaged by bombing in 1941. It had to be demolished, but a replacement was later built on almost exactly the same site. The grounds are shared with Digby Stuart College as part of the Roehampton Institute.

Roehampton Lane c1907. The chapel of the Convent of the Sacred Heart is on the left. The trees are casting a shadow across the whole carriageway, which was not much more than twenty feet wide, a good reason for the road widening that took place in this area in the late 1950s.

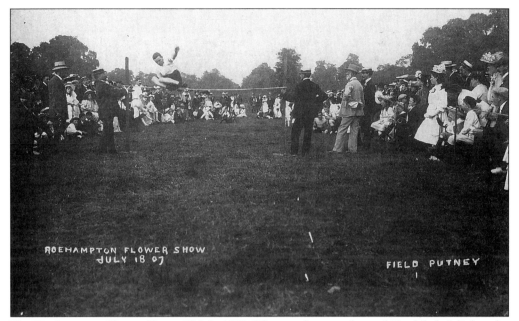

The Roehampton Flower Show, 18 July 1907. The weather was deemed 'So delightful' that the Roehampton Flower Show, Industrial Exhibition and Sportsday, to give it its full title, was held on the heath near the boy's school. Here, one of the schoolboys is successfully clearing the high jump.

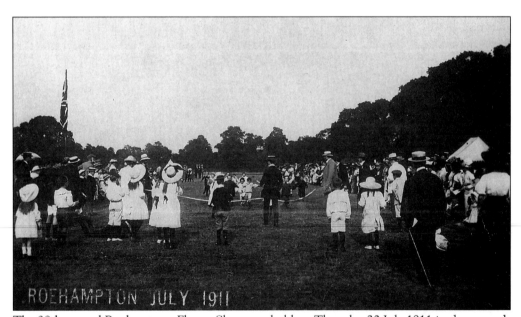

The 38th annual Roehampton Flower Show was held on Thursday 20 July 1911 in the grounds of Dover House thanks to the generosity of the owner, John Pierpoint Morgan. Little boys can be seen running towards the tape in one of the sporting events.

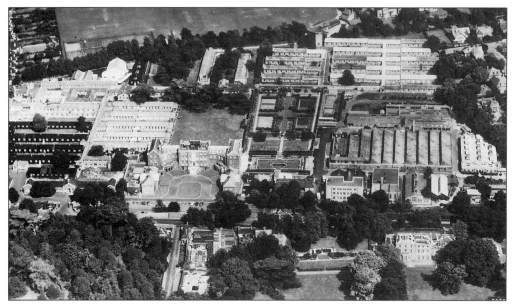

Queen Mary's Hospital, Roehampton Lane. The upper view of c1950 shows Roehampton House to the left of centre surrounded by the hospital wards; the lower view is from c1945 and shows the wonderful trees in the garden where patients could stroll and recuperate. Roehampton House was built 1710-12 for Thomas Cary by Thomas Archer. Among the residents was William-Anne Keppel, 2nd Earl of Albermarle. In 1791 William Drake MP purchased the house and grounds. Throughout the nineteenth century various Earls of Leven and Melville lived in the house. In 1910 the financier Arthur Morton Grenfell bought the house and commissioned Sir Edward Lutyens to carry out alterations which included erecting the three-storey wings to both sides of the house.

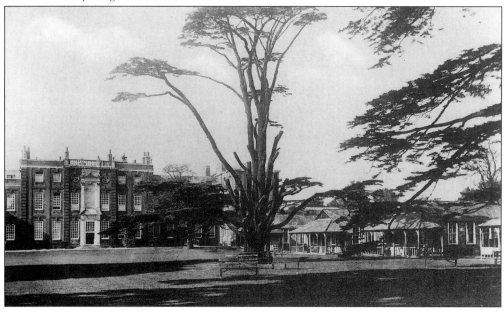

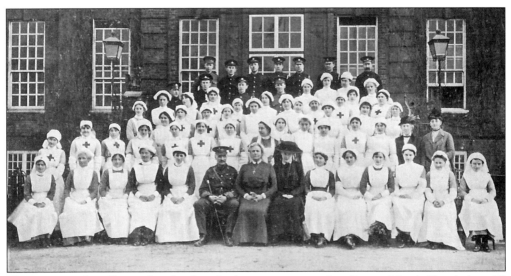

The nurses and staff seen shortly after the house was opened as Queen Mary's Hospital on 28 June 1915 to administer to limbless service men. A limb fitting centre was added, together with wards in the gardens and grounds. The patients were issued with a blue outfit and sported a red tie as seen worn by the men in wheelchairs. The hospital's range of treatment increased throughout the Second World War and amongst its successful patients was Wing Commander Douglas Bader. The house was bombed during the Second World War, and the painted ceilings of Sir James Thornhill, which he completed shortly after the house was erected, were destroyed.

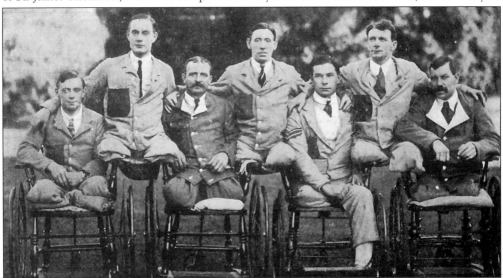

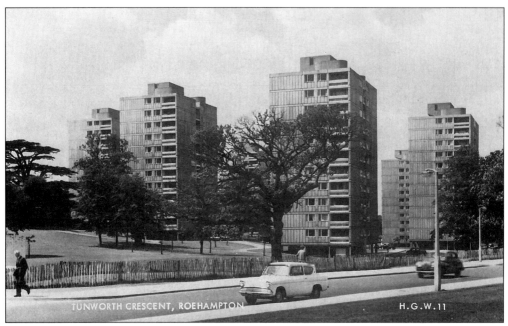

Tunworth Crescent, Alton West estate, c1960. This housing estate was started in 1954 and the main building works were completed by 1957. The blocks were built to take into consideration the landscape either side of Danebury Avenue and the natural slope leading down from Clarence Lane.

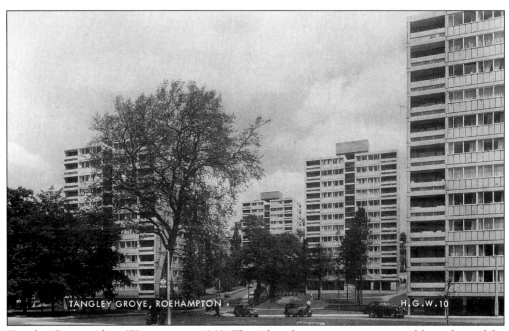

Tangley Grove, Alton West estate, c1960. The Alton housing estate was quickly acclaimed for its architectural merit combined with sympathy for the setting; it has been mentioned in many books on postwar architecture and visited by many overseas students.

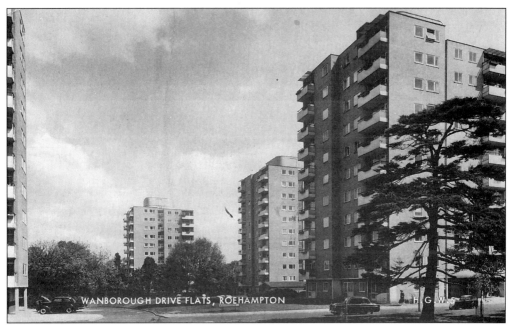

Wanborough Drive, Alton East estate, c1960. The LCC started building on the site in 1952 and the housing estate was largely finished by 1956.

Fairacres, Roehampton Lane, 1937. This unusual shaped block of private flats was built in 1937.

The junction of Priory Lane and the Upper Richmond Road c1912. The speed limit sign of 10 m.p.h. finishes with the words 'By Order', but neglects to mention by whose! The original name was Clarence Lane; the present name was given partly to distinguish from the other lane, but also for the Priory situated here.

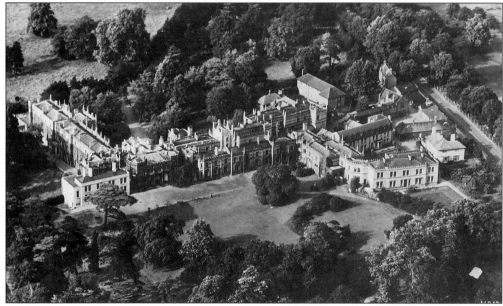

The Priory c1950. The Priory was built shortly before 1811 on land owned by Sir Thomas Bernard, and together with forty acres of parkland was sold in 1811 for £11,000 to Sir Henry James Craig, Governer of Canada, who died in 1812 before taking up residence. By 1839 Sir James Lewis Knight Bruce, an early member of the Lords Justice of Appeal, lived here and converted the building into its present Tudor style with battlements. It became a nursing home, caring for nervous and mentally disturbed patients, in 1871. Separate bed-sitting rooms were provided for ninety patients together with a chapel and operating theatre. The northern part of the estate was sold off and developed in 1969-70 by the GLC as an housing estate.

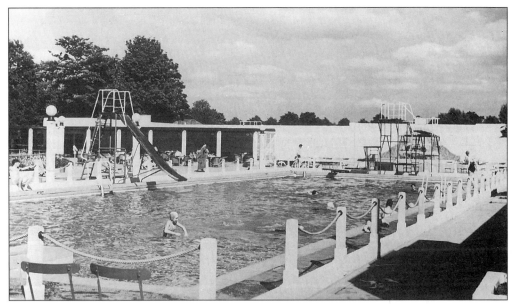

The swimming pool in Priory Lane was a privately run open-air facility operated by Roehampton Swimming Pool Ltd. The pool was in operation by 1936 and survived up to the 1960s. The Woking Close housing estate was subsequently built on the site.

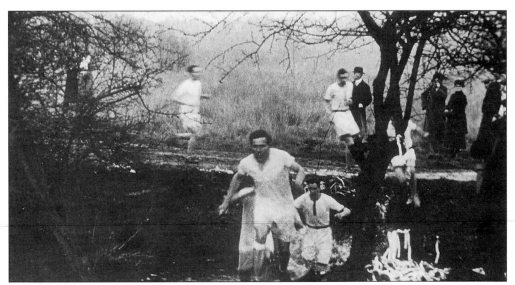

A Varsity cross-country race at Roehampton c1935. The King's Head public house in Roehampton High Street is where the first cross-country club in England, the Thames Hare and Hounds, had its headquarters. The earliest races in 1868 were held as winter training sessions for the boat crews of boat clubs at Putney. The heath above Roehampton is still used for cross-country running.

The Putney Picture Framing Manufacturing c1905. The proprietor was George Hadfield and the address was first given as 11 Emily Terrace, Coopers Arms Lane, but in the renaming of the lane by the LCC the address became 34 Lacy Road.